IMAGES
of America

GARY'S WEST SIDE

THE HORACE MANN NEIGHBORHOOD

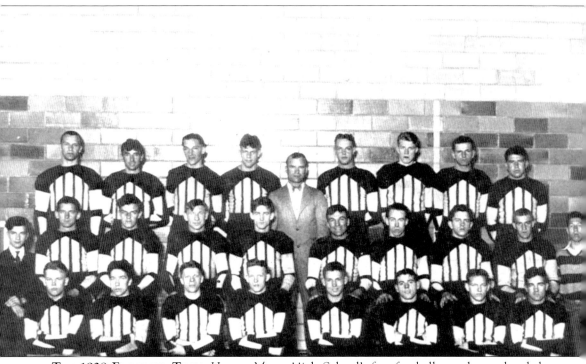

THE 1928 FOOTBALL TEAM. Horace Mann High School's first football squad completed the season with an impressive 6-1-1 record in the fall of 1928. The only loss was a 14-13 heartbreaker to Gary Froebel near the end of the season. (Courtesy of the Calumet Regional Archives.)

IMAGES *of America*

GARY'S WEST SIDE
THE HORACE MANN NEIGHBORHOOD

John C. Trafny

Published by Arcadia Publishing
Charleston SC, Chicago IL, Portsmouth NH, San Francisco CA

Printed in Great Britain

Library of Congress Catalog Card Number: 2005934408

For all general information contact Arcadia Publishing at:
Telephone 843-853-2070
Fax 843-853-0044
E-mail sales@arcadiapublishing.com
For customer service and orders:
Toll-Free 1-888-313-2665

Visit us on the internet at http://www.arcadiapublishing.com

On the cover: **HORACE MANN SCHOOL.** Horace Mann School opened its doors in the fall of 1928. In its early years, the school served students from kindergarten through the 12th grade. In the spring of 2004, the school closed after the last students departed its hallowed halls. The view is of the school's southeast side near the pond. (Courtesy of Calumet Regional Archives.)

CONTENTS

ACKNOWLEDGMENTS

When my second book, *Gary's East Side*, was released in 2002, a number of Horace Mann graduates congratulated me and suggested a book about their old West Side neighborhood. Being an old Eastsider, and a graduate of Emerson High School, I began to do research on the area and its history. Horace Mann was our biggest rival in sports, academics, and everything else. Emerson students dated Mann students and vice versa, and the competition between the two schools, both on and off the athletic field, often resembled a 15-round heavyweight boxing match.

The neighborhood has had a long and proud history. It was a symbol of the achievement of the American dream. Grand homes stood along many of its quiet, tree-lined streets. Children of the wealthy went to school and made lasting friendships with many of those from the middle class. Local businesses flourished during the years that Gary was the destination of shoppers from throughout the Calumet Region.

Every picture has a story. By presenting the book as a pictorial history, I wanted each reader to rekindle his or her own personal memories of the people and places that were pictured. Some may find their family members, friends, sweethearts, or former teachers in the old photographs. Others may recall events that helped shape their lives. They might be historic, like the Depression or World War II, or personal, such as the prom, graduation, an athletic event, or where they used to hang out with friends. *Gary's West Side: The Horace Mann Neighborhood* will provide many fond memories to those who once lived there and to those who still do.

A number of people were very kind in offering their time and personal assistance as well as providing me with a wealth of material and information. Stephen G. McShane, the archivist of the Calumet Regional Archives at Indiana University Northwest, assisted in locating old photographs and volunteered his time to do computer scanning. Diane Trafny-Greenwood, my sister and coauthor who typed all the information, did all of the proofreading, and did not hesitate to offer her critiques. Stephen Greenwood, my nephew, offered his technical assistance with any computer problem. Don Mueller, a graduate of Holy Angels, provided me with photographs of the school and neighborhood. Tom Campbell, also from the Mann neighborhood and my former teacher, shared family photographs and class pictures from Holy Angels. Sister Kathleen Quinn, from Holy Angels, provided old parish photographs and historical information on Holy Angels. Millie Ivankovich, a Horace Mann grad, provided information on people and places around Horace Mann. Dr. Warren E. Johnson was kind to send me historical information on the First Presbyterian Church on West Sixth Avenue. Tom Higgins, formerly of WWCA Radio, shared historical information on Holy Angels and Horace Mann. Dr. James B. Lane and Dr. Ronald D. Cohen's books on Gary's history provided much-needed background material. The late Dr. Edward Zivich, my former instructor at Calumet College, encouraged me in the study of the Calumet Region. Dr. Lance Trusty, professor of history at Purdue University, provided his time and encouragement for the publication of *The Polish Community of Gary*. Finally, to Ann Marie Lonsdale and Arcadia Publishing for their help, encouragement, and patience. Of course, no historical research can be perfect, and the author assumes full responsibility for any and all errors or omissions herein.

INTRODUCTION

In 1906, United States Steel Corporation began construction of a massive steel production facility along the southern shore of Lake Michigan. At the same time, just south of the plant, a modern planned city took shape. Gary, Indiana, would become home to the thousands of workers needed to build and later operate the new mills. From all parts of the country, as well as southern and eastern Europe, skilled and unskilled workers flocked to the Calumet Region seeking gainful employment.

Within a few years, neighborhood boundaries were established, dividing areas by major streets or railroad lines. The Wabash Railroad tracks separated residents by income and ethnic origin. Immigrants and unskilled workers resided in the Steel City's South Side, while skilled craftsmen and professional people settled north of the tracks. A short time later, the West Side, later Gary's Horace Mann neighborhood, evolved into one of the most exclusive residential areas in the region.

Steel executives, mill supervisors, and professional people built large, elegant homes along tree-lined streets. Large, stately apartment buildings went up along Fifth Avenue and other major streets. But the area was not limited to those of the "upper crust" of the Steel City. Skilled craftsmen, teachers, and small business owners were able to purchase decent homes as well. Located just south, and within walking distance of the noise and smoke of the steel mills, the Horace Mann community became a posh neighborhood within an urban, industrial city.

Mann residents shopped along Broadway in large department stores and expensive specialty shops. Gary's downtown attracted consumers not only from the city but also from surrounding communities and even Chicago. Sidewalks and stores were often packed with shoppers, especially on Saturdays and payday Monday. Small, profitable local businesses, operated along West Fifth Avenue as well as Washington Street. During the boom times of the 1920s, and the 20 years after World War II, the area was thriving.

Beautiful churches and synagogues that provided for the spiritual needs of their Protestant, Catholic, and Jewish congregations were located throughout the neighborhood. Like the local schools, the houses of worship brought people of diverse economic groups together in prayer and helped build a sense of community. Residents walked together to prayer services, joined social organizations established by members of the congregation, and helped pass on religious teachings and traditions to their children.

In 1906, the Diocese of Fort Wayne, Indiana, established Holy Angels Parish at Sixth Avenue and Tyler Street to serve the growing Roman Catholic population in the area. An elementary school, staffed by the Sisters of Notre Dame, was opened to provide a Catholic education for the children of the parishioners. By the late 1950s, the Diocese of Gary was born with the consecration of the Most Reverend Andrew G. Grutka as bishop. Holy Angels Cathedral replaced the old church.

Horace Mann School opened its doors in 1928 and offered a public education for students from the elementary grades through high school. The first high school graduates received their

diplomas in 1929. Named for the 1840s educational reformer, Horace Mann School became a model for academic and athletic excellence. Dedicated teachers inspired students to pursue their future academic or career goals. The school's athletic teams won numerous city, conference, and state titles.

For over four generations, the Horace Mann neighborhood stood as an example of successful city planning, personal involvement, and stability. Residents both young and old took special pride in their community. Though a great deal has changed over the last 25 years, those who lived there, and those who wished they did, have many recollections of the Horace Mann neighborhood. It is hoped that the book *Gary's West Side: The Horace Mann Neighborhood* will rekindle many of those memories.

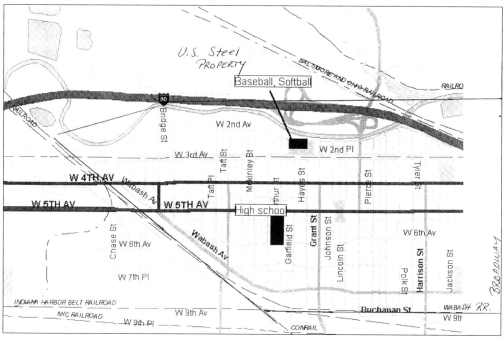

COMMUNITY BORDERS. Gary's Horace Mann community was bordered by the U.S. Steel property to the north and the downtown shopping area along Broadway to the east. The Wabash Railroad ran along its southern border, while the old Pennsylvania Railroad line served as the western boundary. (Courtesy of Calumet Regional Archives.)

One

THE NEIGHBORHOOD

Gary's Horace Mann neighborhood was situated just west of Broadway and south of U.S. Steel's Gary Works. Many people recall it as an area of stately homes with beautifully landscaped yards. Grand apartments lined Fifth Avenue and other major streets. Elegant parks with tree-lined walkways provided residents with a place to stroll, relax, and meet friends.

Impressive structures such as the Knights of Columbus Building, City Methodist Church, the Gary Hotel, the Ambassador Apartments, and the old Gary-Hobart water tower brought back memories of another era. Other classic buildings fell to the wrecker's ball. The old main public library, YMCA, Masonic temple, Jefferson School, and the Tivoli Theater became memories.

To those who lived there it was home. They grew up in their parents' houses, formed lasting friendships, walked to the neighborhood schools, and got groceries at the corner store. A few got into mischief and on occasion were caught and made to face the consequences. Many dated, and later married, sweethearts, and like their parents, they also raised families in the neighborhood.

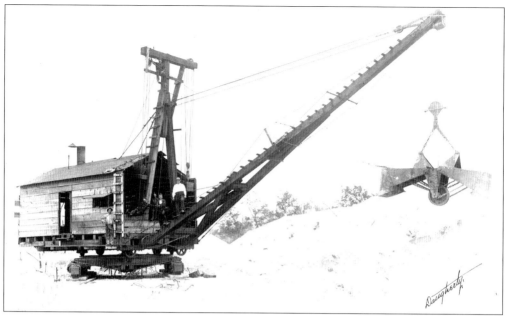

CRANE REMOVING SAND. With the coming of industrial giant United States Steel Corporation, a whole new city would have to be created for the thousands that would seek employment at the new plant. Trees had to be cut down, swamps drained, and tons of sand removed. Here the crew of a huge crane takes a picture of what would become Seventh Avenue and Lincoln Street. (Courtesy of Calumet Regional Archives.)

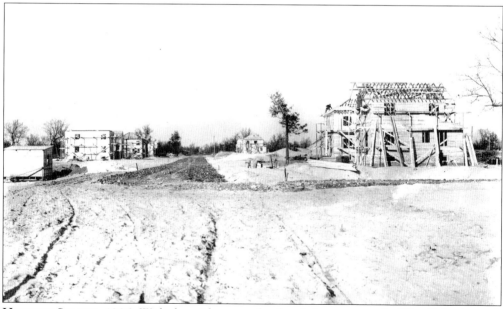

HOUSING STARTS, 1906. With the grid pattern for the city's streets on the West Side planned, housing construction began at a quick pace. Travel through the area was still difficult, as the roadbed was nothing more than sand in many places. At the intersection of Seventh Avenue and Jefferson Street plenty of choice lots were available. To the right, a worker is installing the roof in 1906. (Courtesy of Calumet Regional Archives.)

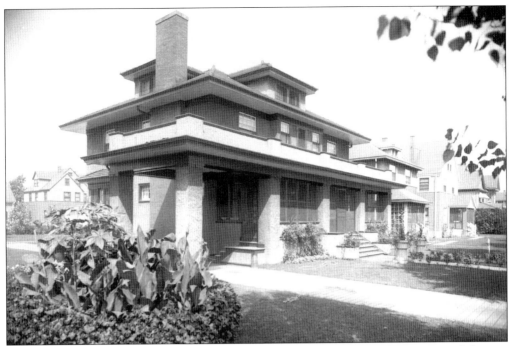

HOUSE AT 630 JACKSON STREET. A good number of homes on the Steel City's West Side were two-story structures built on lots 40 feet wide or larger. Many of these homes were purchased by skilled craftsmen or management personnel who worked at the mill. This house was located at 630 Jackson Street in 1915. (Courtesy of Calumet Regional Archives.)

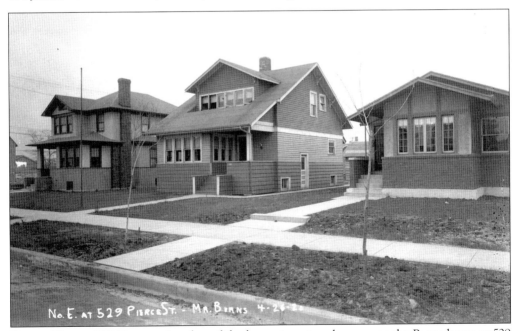

BURNS HOME, 529 PIERCE. Another of the larger two-story homes was the Burns home at 529 Pierce Street. This picture, taken in April 1920, is looking northeast. (Courtesy of Calumet Regional Archives.)

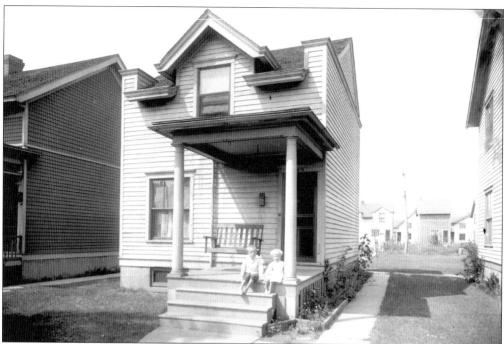

HOUSE AT 348 TYLER STREET. For young families starting out and not in the higher income brackets, a number of smaller homes were available. One style, called the V-2, was available through the Gary Land Company and located at 348 Tyler Street. Children are posing for the camera on the back porch in August 1915. (Courtesy of Calumet Regional Archives.)

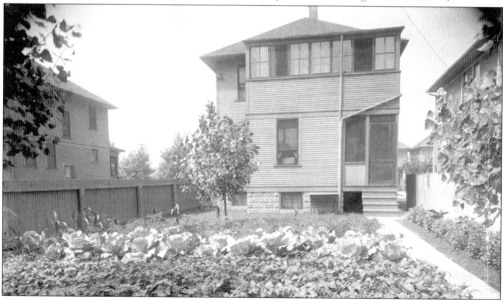

GARDEN AT 445 MONROE STREET. Vegetable gardens were a common sight throughout the city in 1917. With America's entry into the Great War that year, growing vegetables was encouraged by the government. A lot 30 to 40 feet wide provided ample space for a good crop as long as the weather cooperated. The picture shows the backyard of the home located at 445 Monroe Street. (Courtesy of Calumet Regional Archives.)

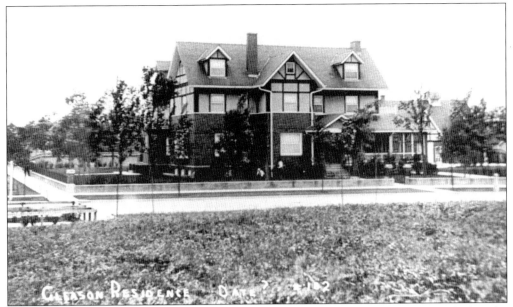

GLEASON HOME. Corporate executives, business owners, and professional people flocked to the neighborhood and resided in elegant homes. William Palmer Gleason, the first superintendent of U.S. Steel's Gary Works, resided in this home, pictured around 1920. (Courtesy of Calumet Regional Archives.)

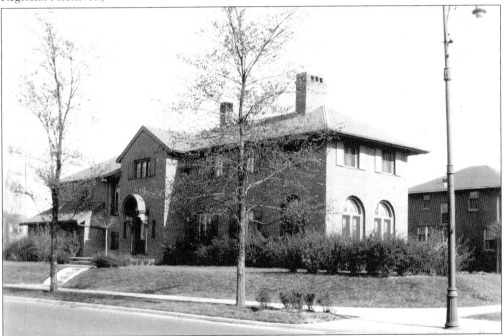

J. R. SNYDER HOME. When the Steel City's first chief executive, Tom Knotts, discontinued his interest in the *Gary Evening Post*, the Snyder family bought control of the newspaper. From 1910 until the early 1960s, J. R. "Ralph" Snyder and his brother H. B. "Bud" Snyder played a major role in shaping local public opinion. The J. R. Snyder home was located at 601 Johnson Street. The picture was taken in the late 1920s. (Courtesy of Calumet Regional Archives.)

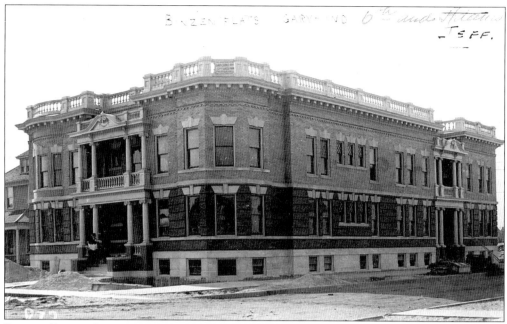

BINZEN FLATS, SIXTH AND ADAMS. Even though new housing was being constructed at a record pace, the demand still exceeded available living quarters. To meet the needs of the new settlers who would work at the new steel plant, a number of rental properties were built on the city's near west side. At Sixth Avenue and Adams Street, the Binzen Flats were opened to renters. (Courtesy of Calumet Regional Archives.)

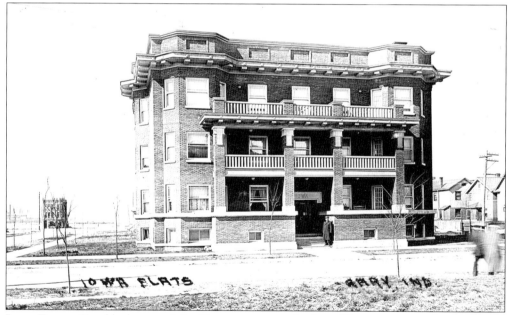

IOWA FLATS. One block west of the Binzen property, the Iowa Flats were opened to renters at 328 West Sixth Avenue. In the photograph, new housing is visible to the right of the building. To the left, only one structure stands out in an area of vacant lots. Within a few years, the entire area would be filled with homes and apartments. (Courtesy of Calumet Regional Archives.)

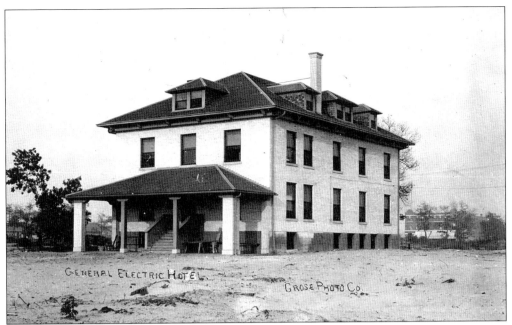

GARY GENERAL. Before 1920, professional medical care could only be found in three facilities. St. Mary's Mercy was run by the Franciscan Sisters, while the Illinois Steel Company operated a hospital on Broadway for the mill employees. A third hospital, Gary General, provided care to residents from the building near Fourth Avenue and Adams Street. Originally it opened as the General Electric Hotel. (Courtesy of Calumet Regional Archives.)

WEST SIDE PARK. When U.S. Steel laid out the new steel town, they called for a number of parks to be built for the residents. West Side Park, located at Sixth Avenue and Madison Street, provided a place to relax and take a stroll. The original administration building is pictured here in 1921. Today it is known as Borman Park. (Courtesy of Calumet Regional Archives.)

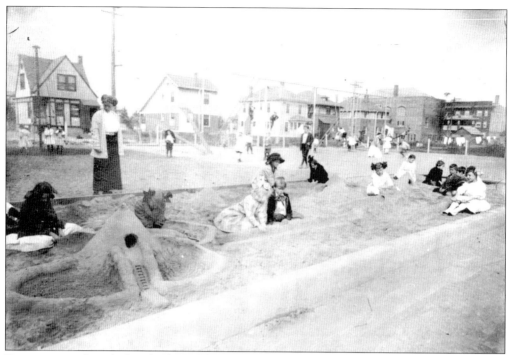

PLAYGROUND. Long before the days of electronic gadgets and computers, children still found a way to have fun. Here youngsters enjoy themselves playing in the sand at a playground near Jefferson School, visible at the far right, before 1920. (Courtesy of Calumet Regional Archives.)

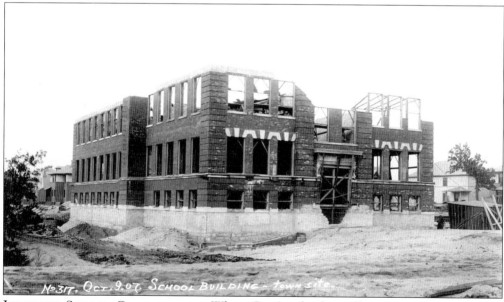

JEFFERSON SCHOOL CONSTRUCTION. When Gary's school enrollment grew to nearly 500 students, a new school was constructed to replace the structure at Fourth Avenue and Broadway. Jefferson School was constructed at Seventh Avenue and Jefferson Street in the fall of 1907. Two years later, Gary's first high school, Emerson, would open its doors. (Courtesy of Calumet Regional Archives.)

JEFFERSON SCHOOL, 1936.
Jefferson School is shown here
in 1936. The school closed
years ago and has since been
demolished. (Courtesy of
Calumet Regional Archives.)

AMBRIDGE SCHOOL, 1920S. Located along West Fourth Avenue was Ambridge Elementary
School, pictured here in the late 1920s. Due to continued declining enrollment, the school was
closed some years ago. Today it is home to the Gary Historical Society. (Courtesy of Calumet
Regional Archives.)

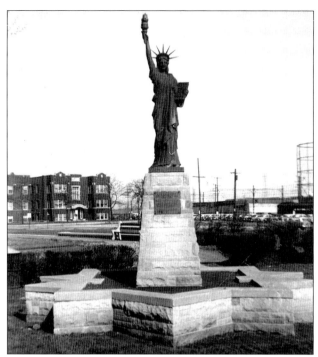

GATEWAY PARK. In the early 1950s, Robert Welsh, who established Welsh Oil, provided the funds for the Statue of Liberty monument located on the west side of Gateway Park. It was dedicated in a special ceremony with the city's Boy Scout units. The statue still stands today, but the apartments in the background were torn down to make way for the transportation center and new South Shore Railroad station. (Courtesy of Calumet Regional Archives.)

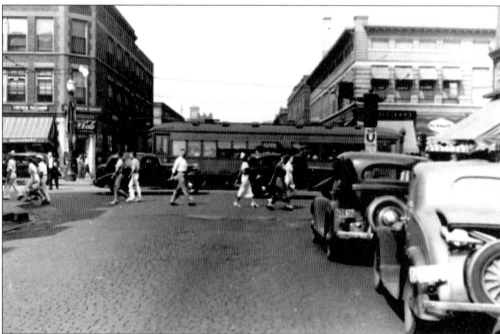

SEVENTH AND BROADWAY. In this photograph, taken on August 10, 1936, it appears to be a typical Monday morning along Broadway, the city's main commercial thoroughfare. Streetcars and automobiles rumble through the street while shoppers fill the sidewalks. The nation was still in the grip of the Great Depression, and in a number of communities, recovery was years away. However, Gary was beginning to see a steady economic upturn. This picture was taken at Seventh Avenue and Broadway looking west. (Courtesy of Calumet Regional Archives.)

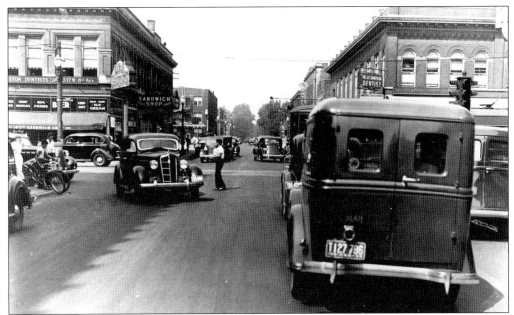

EIGHTH AND BROADWAY. A few minutes later, the photographer took this picture at Eighth Avenue and Broadway looking west. It was for a traffic study of major intersections throughout the city. A pedestrian tries to negotiate his way across the busy street. The buildings to the left and right housed shops and restaurants on the ground floors while the upper levels contained the offices of local dentists, doctors, and other professionals. The two structures were demolished years ago. (Courtesy of Calumet Regional Archives.)

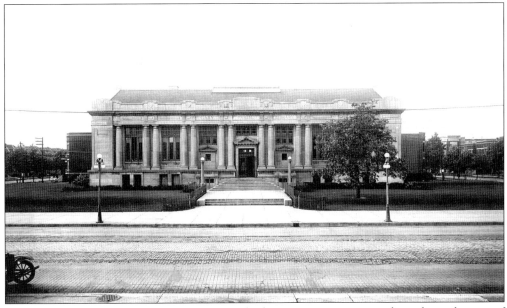

OLD PUBLIC LIBRARY, 1920. Libraries were built in every community throughout the city of Gary. The main branch was placed in the Horace Mann district and located at Fifth Avenue and Adams Street. Pictured here in 1920, it was torn down and replaced with a new structure in the early 1960s. (Courtesy of Calumet Regional Archives.)

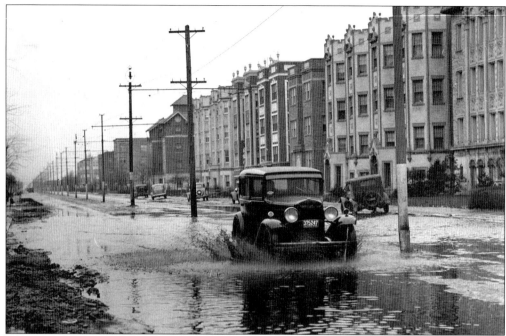

SPRING THAW, 1920s. A driver takes a chance through a flooded area of Fifth Avenue and Hayes Street near Horace Mann School in the 1930s. With rising late-winter temperatures, fast-melting snow made puddles into small lakes. Many roads became obstacle courses testing the skills and patience of drivers as well as giving the vehicles a workout. (Courtesy of Calumet Regional Archives.)

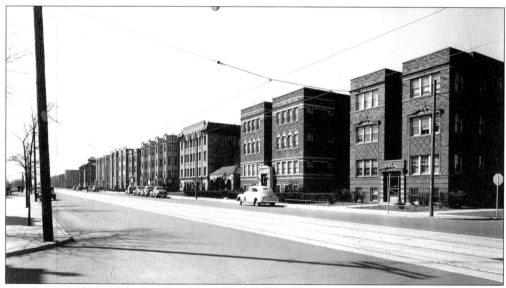

WEST FIFTH AVENUE, 1950s. This is the same area of West Fifth Avenue as it appeared in the 1950s, under ideal conditions. Improved storm sewers kept flooding problems under control. In the 1980s, many of the classic apartment buildings were renovated after years of neglect. Today the Horace Mann neighborhood has undergone a tremendous revival. (Courtesy of Calumet Regional Archives.)

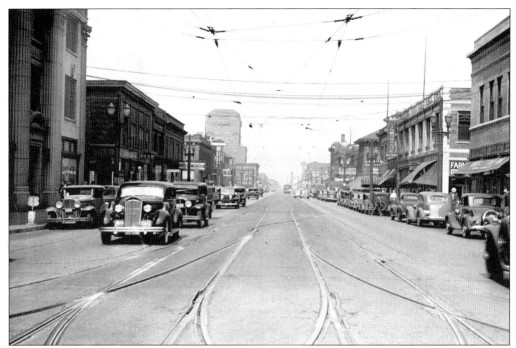

WEST FIFTH AVENUE, 1936. Though the Gary Railway Company could take commuters any place in the city, automobiles were taking away passengers. The view is of West Fifth Avenue from Broadway in 1936. In the background is the Knights of Columbus Building. Fifth Avenue was the main east-west route through the Horace Mann neighborhood, which was home to numerous local businesses including grocery stores, shops, and automobile dealerships. (Courtesy of Calumet Regional Archives.)

FOURTH AND BUCHANAN, 1946. Morning mill traffic was backed up in September 1946 at the intersection of Fourth Avenue and Buchanan Street. With the post–World War II economic boom underway, more people were able to purchase that new family car. Of course, that led to increased traffic congestion throughout the Steel City. (Courtesy of Calumet Regional Archives.)

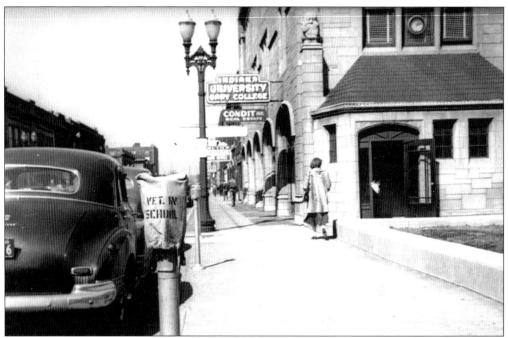

GARY COLLEGE, 1946. Gary College, which became Indiana University in 1948, conducted classes at Seaman Hall. Classes were held there until 1959, when the school moved to 3400 Broadway in Glen Park. This picture was taken in September 1946. Notice the cover over the parking meter, Vet in School. Many veterans were taking advantage of the GI Bill to continue their education. (Courtesy of Calumet Regional Archives.)

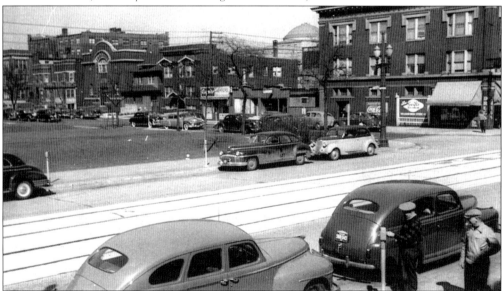

PARKING, FIFTH AND ADAMS. During World War II, America's automobile plants built cars for the military and not for personal use. But in 1946, with a booming postwar economy, new vehicles were available once again. With more cars, shoppers in Gary often had to park a block or two off of Broadway. Here two men are feeding the meters at Fifth Avenue and Adams Street. Back then it was a penny for 30 minutes. (Courtesy of Calumet Regional Archives.)

MASONIC TEMPLE, 1931. Many fraternal and social organizations were located in the Horace Mann community. Gary's Masonic temple conducted business from this grand structure at 250 West Sixth Avenue. The picture was taken in April 1931. (Courtesy of Calumet Regional Archives.)

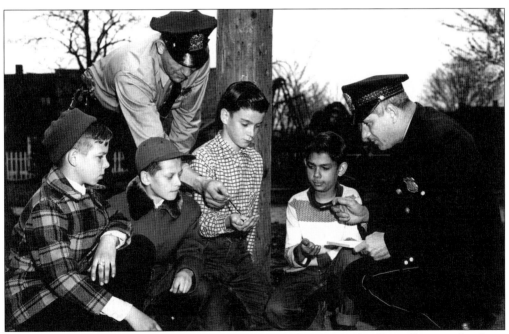

MARBLE TOURNAMENT, 1954. Gary police officers Paul Cessna and Bill Mueller provide advice to youngsters taking part in a marble tournament at Jackson Park in 1954. The Horace Mann neighborhood was much more than familiar buildings, houses, or streets. It was made up of parents raising children, relatives getting together on Sundays, and friends sharing experiences together. Though many of the people have moved on to other areas, all have fond memories of their times in their old neighborhoods. (Courtesy of Don Mueller.)

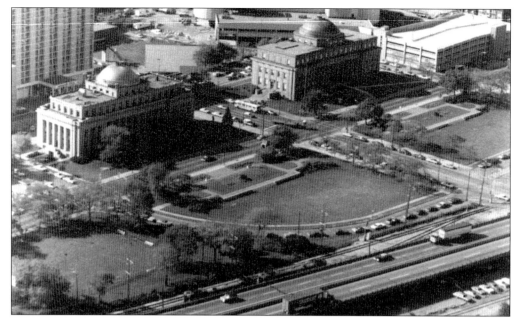

GARY'S GATEWAY. This aerial view shows Gary's gateway at the intersection of Fourth Avenue and Broadway in the 1980s. Visible is the former Sheriton Hotel, city hall, the superior court building, and the Genesis Center. The grassy area is Gateway Park. (Courtesy of Calumet Regional Archives.)

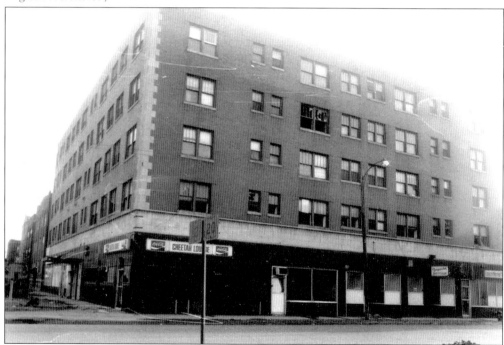

GATEWAY APARTMENTS. Across the street from the county court house was the Gateway Apartment Building. After years of neglect, it was finally torn down to make way for the county parking garage. It is pictured here in the late 1970s at the intersection of Fourth Avenue and Washington Street. (Courtesy of Calumet Regional Archives.)

TRANSPORTATION CENTER. Since the 1980s, the area west of Broadway has undergone a great deal of change. The old South Shore station is long gone. In its place is the transportation center at Fourth Avenue and Adams Street next to Gateway Park. It is pictured here in 2005. (Courtesy of Calumet Regional Archives.)

PRESENT LIBRARY. Gary's present library sits at the intersection of Fifth Avenue and Adams Street across the street from the Genesis Convention Center. It is pictured here in 2005. (Courtesy of Calumet Regional Archives.)

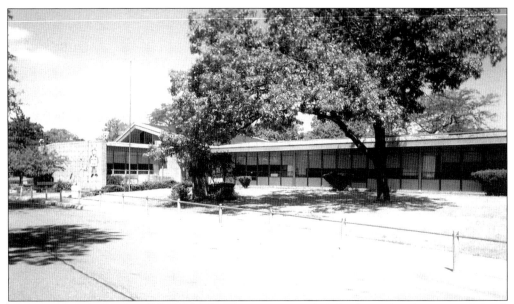

JOHN VOHR SCHOOL. Directly south of Horace Mann High School is Vohr Elementary School. The educational facility was named for John Vohr, a past superintendent of U.S. Steel's Gary Works. Many Mann graduates disliked where the structure was placed, as it brought about removal of part of the wooded area south of the school. Pictured here in 2005, it is still in use today. (Courtesy of John C. Trafny.)

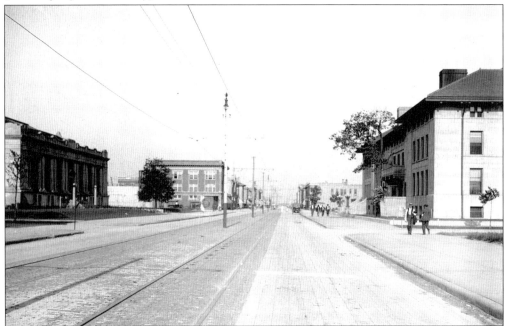

FIFTH AVENUE, 1913. In July 1913, traffic congestion was not a problem on the main streets of the West Side. Automobiles were still considered a luxury, so residents depended on streetcars and their own two feet to get to their destinations. Fifth Avenue near Jefferson Street looked deserted in the middle of the day. The library is at left and the YMCA is on the right. (Courtesy of Calumet Regional Archives.)

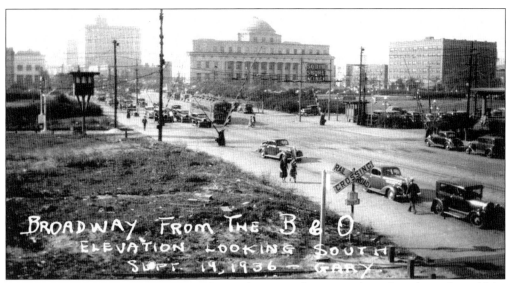

BROADWAY FROM BALTIMORE AND OHIO. A visitor that arrived in Gary by rail would be impressed by the improving local economy. Gradually the city was coming out from the difficult days of the Great Depression. The increasing street traffic around Fourth and Broadway seemed to show this. The photograph, taken from the Baltimore and Ohio Railroad station in the late 1930s, is looking southeast. (Courtesy of Calumet Regional Archives.)

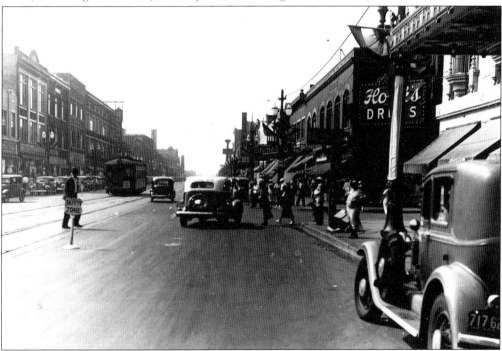

SIXTH AND BROADWAY, 1936. Though jobs were still scarce and family budgets were still limited, people continued to purchase necessary items when they had some extra cash. Because of a slow but steady flow of shoppers, many stores remained in business. Looking south from Sixth Avenue and Broadway, shoppers continue to patronize stores such as Goldblatts, Richmond Brothers, and Hooks Drugs in 1936. (Courtesy of Calumet Regional Archives.)

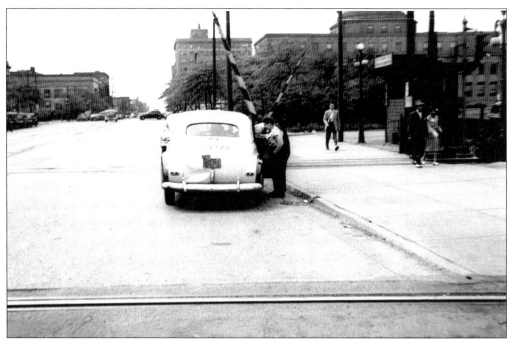

SOUTH SHORE COMMUTER. In addition to an excellent public transportation system, Gary was connected to much of the region and nation by bus and rail. Rail lines such as the old Baltimore and Ohio, New York Central, as well as the South Shore had depots on Broadway. Here a commuter settles with the cab driver by the South Shore station north of the downtown area in 1946. (Courtesy of Calumet Regional Archives.)

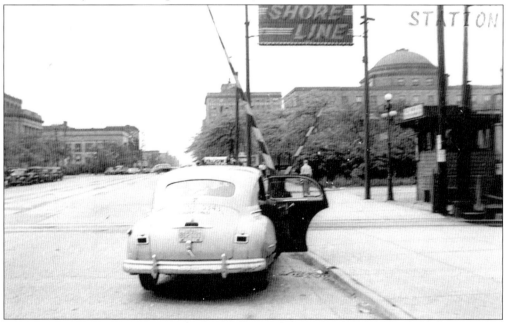

OPEN CAB BY STATION, 1946. In haste to purchase his ticket and catch the train on time, the commuter leaves the cab door open and departs. Hopefully he left the driver a tip. (Courtesy of Calumet Regional Archives.)

KNIGHTS OF COLUMBUS, 1940S. During the good times of the 1920s, a building boom took place in Gary with the construction of such notable structure as Hotel Gary, the Gary National Bank, and the elegant Palace Theater. On West Fifth Avenue, the ten-story Knights of Columbus Building opened. The building contained stores, a bowling alley, a gym, and a dining hall. Pictured here in the 1940s, the structure was renovated in the 1980s and serves as a senior citizens' residence. (Courtesy of Calumet Regional Archives.)

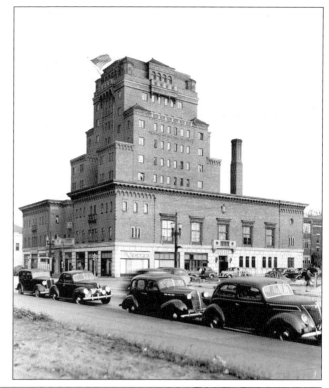

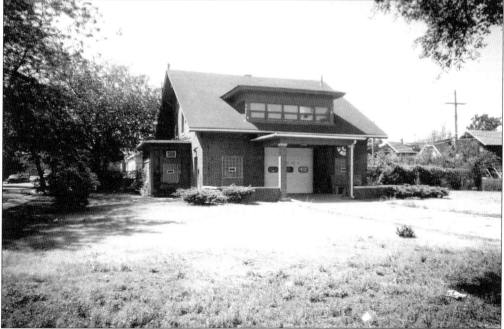

FIREHOUSE NO. 6. Two fire stations protected the city's West Side. Firehouse No. 6, near Horace Mann High School, was located at 1201 West Fifth Avenue. It was called the Dollhouse by many residents because of the special care the firemen gave to the landscape. The building, shown in 2005, has been closed for a number of years. (Courtesy of John C. Trafny.)

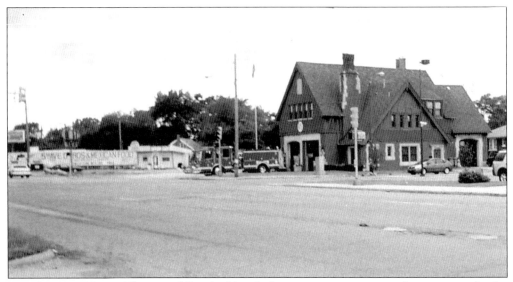

FIRE STATION NO. 8. The city of Gary's oldest firehouse continues to provide protection for the residents of the West Side. In the 1980s, Engine House No. 8 was renovated, but the city and contractors made sure that the classic structure maintained its old-fashioned firehouse flavor. The station is located at the far west side of the Horace Mann neighborhood. (Courtesy of Calumet Regional Archives.)

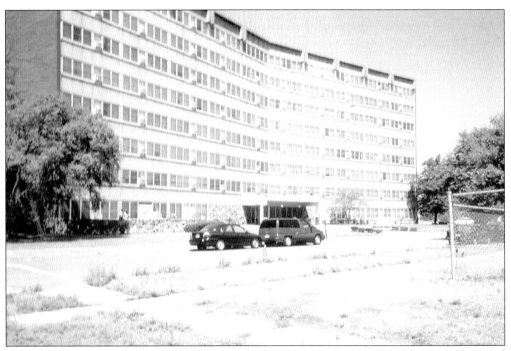

CAROLYN MOSBY HOUSING. With the growing senior population in the city, affordable rental units were in great demand. An eight-story structure was constructed on 666 Jackson Street. It is named after the late state senator Carolyn Mosby, who served the area for many years in the Indiana legislature in Indianapolis. (Courtesy of Calumet Regional Archives.)

POLICE STATION. Many people believed that the city police station, located at Thirteenth Avenue and Broadway, was outdated as soon as it opened. A few years ago, the old Mercy Hospital property on West Fifth Avenue was purchased and renovated by the City of Gary. Today it houses the police station, jail, and city courts. (Courtesy of John C. Trafny.)

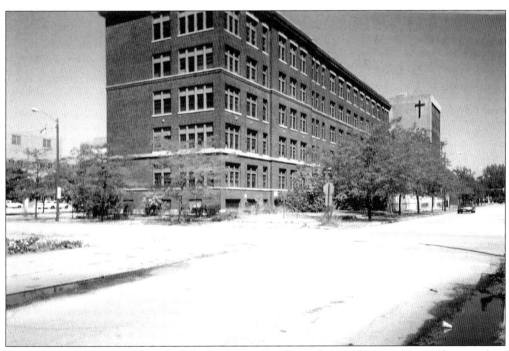

OLD MERCY HOSPITAL. Not all of the buildings that housed the old Mercy Hospital were taken over by the city. Those between Fifth and Sixth Avenues and Tyler Street remain standing, neglected, and boarded up. (Courtesy of John C. Trafny.)

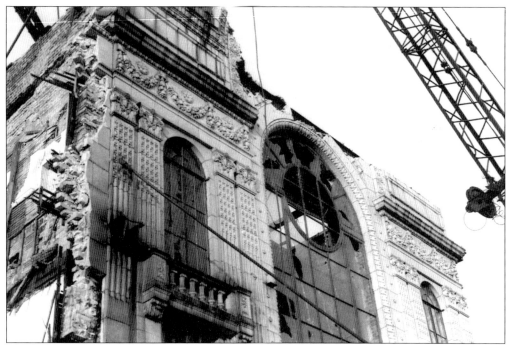

TIVOLI FRONT. During Hollywood's golden era, Gary movie patrons took pride in the movie houses throughout the city. Besides first-run films, some presented plays, vaudeville acts, and concerts. The Tivoli Theater, which operated along West Fifth Avenue, displayed a grand style of architecture like the Palace and Gary Theaters. (Courtesy of Calumet Regional Archives.)

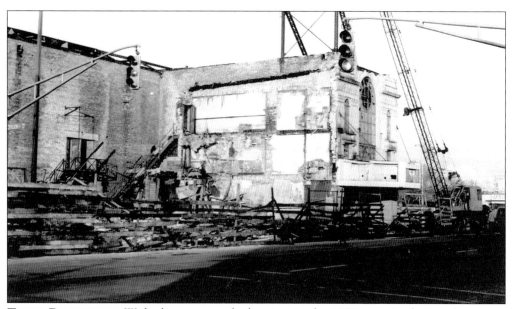

TIVOLI DEMOLITION. With the coming of television in the 1950s, movie theaters lost many paying customers as people stayed home to watch their favorite shows. As business fell off, the Tivoli turned to adult-only features and then closed down. Neglected, the structure was finally torn down. (Courtesy of Calumet Regional Archives.)

OLD METHODIST CHURCH. Still standing but abandoned long ago is the empty shell of the once beautiful City Methodist Church and Seaman Hall at Sixth Avenue and Washington Street. Due to face the wrecker's ball, it is a sad reminder of a neighborhood that was once full of life. Pictured is the north side of Seaman Hall in 2005. (Courtesy of John C. Trafny.)

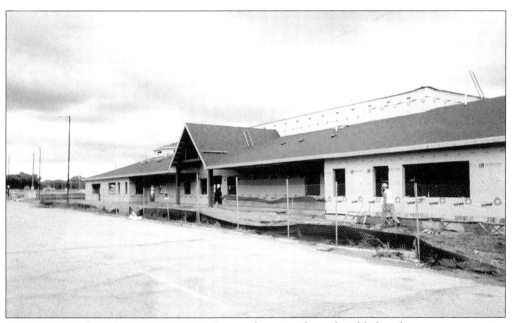

ACROSS FROM OLD CITY METHODIST. Across the street from the old church, a new community is being created. From Washington Street to Jefferson Street, new housing, a community center, and a school are under construction. Workmen are visible in this photograph on the west side of the 600 block of Washington Street. (Courtesy of John C. Trafny.)

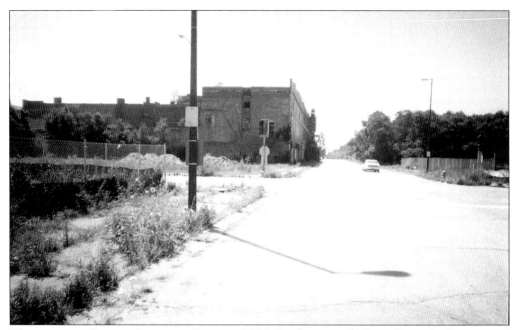

WASHINGTON STREET LOOKING SOUTH, 2005. Looking south from Seventh Avenue and Washington, only a few abandoned structures remain. Empty lots are overgrown with trees and brush. (Courtesy of John C. Trafny.)

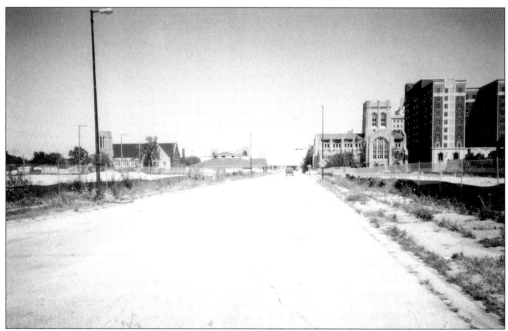

WASHINGTON STREET LOOKING NORTH, 2005. North of Seventh Avenue at Washington, lots are fenced in and marked for new home construction. In the distance, the former Gary Hotel, City Methodist, and Genesis Center can be seen. (Courtesy of John C. Trafny.)

NEW HOME, SEVENTH AND JEFFERSON. One of the models of the homes under construction just west of Broadway is shown here. It sits on the north side of Seventh Avenue at Jefferson Street. (Courtesy of John C. Trafny.)

HOME RESTORED, SIXTH AND PIERCE. In other areas of the Horace Mann community, new housing construction as well as renovation of existing structures takes place. At Sixth Avenue and Pierce Street, a corner house is given new life in the summer of 2005. (Courtesy of John C. Trafny.)

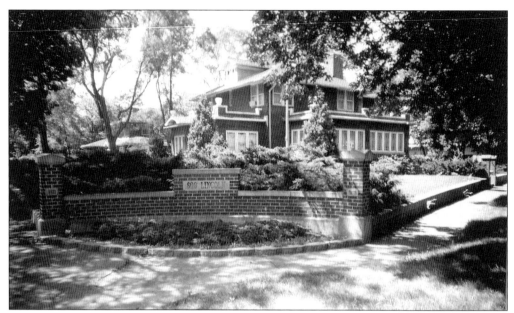

HOMES, SIXTH AND LINCOLN. Though the Horace Mann community has undergone great change over the years, a number of areas have remained the same. Many of the large, stately homes that were built in the early 20th century still stand. They have kept that special charm and beauty people love in an older residential area. Two of those homes are pictured at Sixth Street and Lincoln Avenue in 2005. (Courtesy of John C. Trafny.)

Two

INDUSTRY, UTILITIES, AND TRANSPORTATION

It was Big Steel that gave birth to the infant industrial town of Gary, Indiana, in 1906. Almost overnight, thousands of workers, skilled and unskilled, found employment at the massive plant that rose from the sand dunes along the southern shore of Lake Michigan. At the same time, related industries, such as American Bridge, were established. To provide the growing city with essential utilities, the Gary Heat, Light and Water Company, a subsidiary of U.S. Steel, was created. Railroads, such as the New York Central, Pennsylvania, Wabash, and South Shore, moved people and hauled freight throughout the city.

Across the Grand Calumet River, just north of the Horace Mann neighborhood, were many of the finishing operations of U.S. Steel. In addition, the Elgin, Joliet and Eastern Railroad operated the Kirk Rail Yard to transport raw material needed by the Gary Works in the basic steel-making process. For residents who lived close to the mills, the noise was always there, but few complained about noise pollution. U.S. Steel was the lifeblood of the entire area.

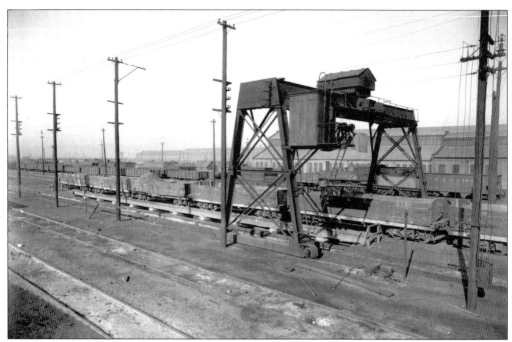

KIRK RAIL YARDS, 1913. When United States Steel Corporation executives agreed on the overall layout of their new plant in Gary, Indiana, the Kirk Rail Yard was designed and put into operation first. Located just west of the main entrance at Broadway, the new facility brought in the materials and supplies necessary for construction of the furnaces and harbor as well as finishing mills that were part of the steel-making process. The yard is pictured in operation in 1913. (Courtesy of Calumet Regional Archives.)

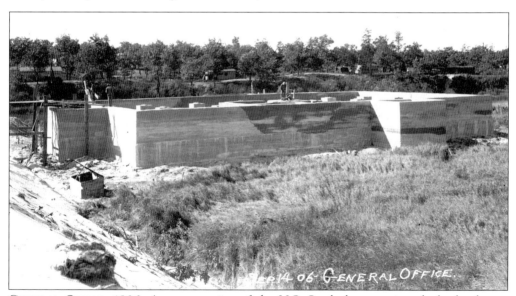

GENERAL OFFICE, 1906. As construction of the U.S. Steel plant continued, the landscape of sand dunes, swamps, and trees underwent a change. Workers completed the foundation of the company's general office building in September 1906. The view is looking southwest from Broadway. (Courtesy of Calumet Regional Archives.)

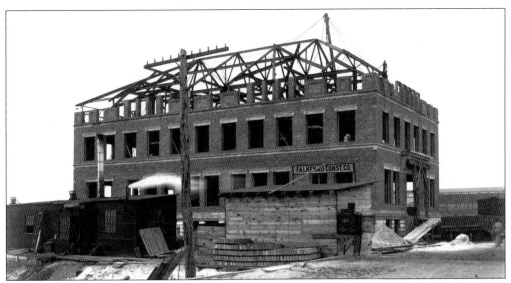

GENERAL OFFICE CONSTRUCTION, 1907. Once the steel support beams were in place, bricklayers went to work to finish the stone walls of the general office building on Broadway. The sign above the windows credits the Falkenau Construction Company for building the structure. This photograph is looking north in April 1907. (Courtesy of Calumet Regional Archives.)

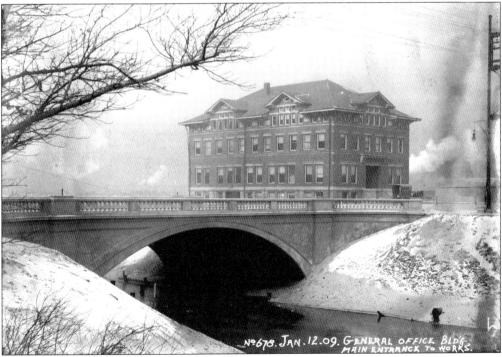

COMPLETED OFFICE, 1909. The completed general office building is shown in 1909 from across the Grand Calumet River. Earlier a huge section of the river was moved nearly 1,000 feet south of its original route. It was considered an engineering feat, as workers had to contend with the swampland and shifting sand. Flies and mosquitoes were often unbearable. (Courtesy of Calumet Regional Archives.)

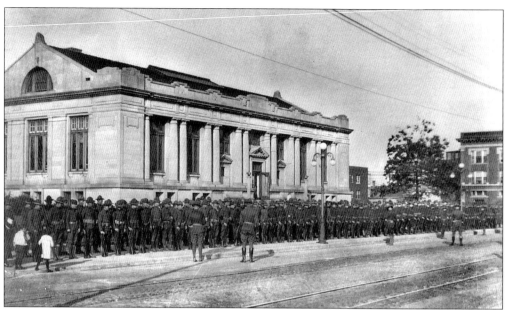

THE 1919 STEEL STRIKE. Labor violence erupted in 1919 after United States Steel Corporation hired scabs to break the union and end the strike. When the state militia failed to restore order, federal troops under Gen. Leonard Wood were sent in. The city was placed under martial law, strike leaders arrested, and eventually the strike was broken. Federal troops are shown assembled outside the old library on West Fifth Avenue. (Courtesy of Calumet Regional Archives.)

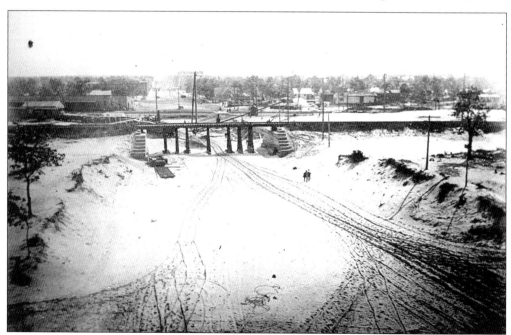

BROADWAY SOUTH FROM MILL, 1906. A number of major east-west railroad lines ran just south of the mill. Rails had to be raised above street level and bridges built to provide easy access for workers and traffic in and out of the plant. The view is south on Broadway around 1906. Some early town structures are visible. (Courtesy of Calumet Regional Archives.)

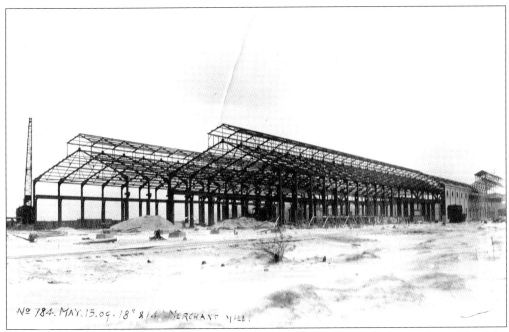

No 784. MAY.15.09. 18" & 14" MERCHANT MILL.

MERCHANT MILLS, 1909. As construction of the steel plant continued, the northern side of the city rapidly changed. Huge structures sprang up almost overnight. Here the steel frame of the Merchant Mills is shown in May 1909. (Courtesy of Calumet Regional Archives.)

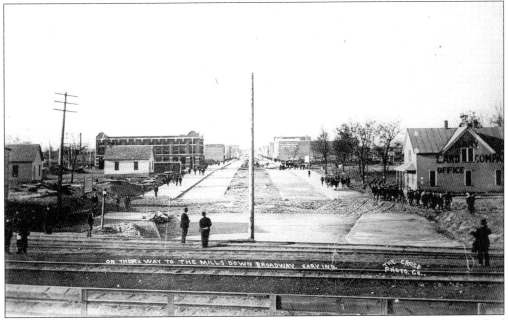

ON THEIR WAY TO THE MILLS DOWN BROADWAY. GARY IND.

THE CROSE PHOTO. CO.

ON WAY TO MILL, 1908. In 1908, nearly all of the people who worked in the mills walked there or took the streetcar. Only the plant supervisors went by automobile. Workers can be seen headed toward the plant for the next shift just outside the Broadway gate. On the right is the Gary Land Company office, which still stands today a few blocks east in Gateway Park. (Courtesy of Calumet Regional Archives.)

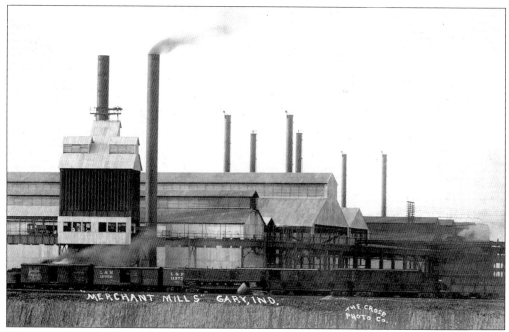

MERCHANT MILLS, 1912. The Merchant Mills, located north of the Horace Mann neighborhood, are shown in operation around 1912. (Courtesy of Calumet Regional Archives.)

TIN PLATE MILL. Farther west were a number of finishing mills that produced flat-rolled steel. An early photograph shows the American Tin Plate Company. (Courtesy of Calumet Regional Archives.)

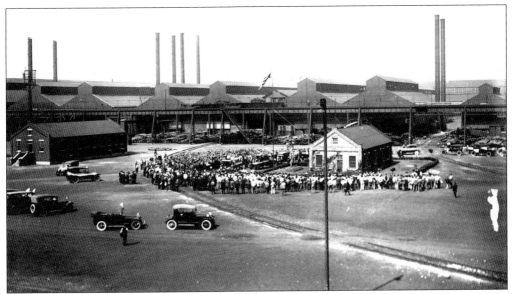

FLAG RAISING, 1918. With American troops fighting in Europe in 1918, civilians on the home front were asked to do their part to help win the war. Besides buying bonds and raising production quotas of steel, workers also took part in patriotic activities. A flag-raising ceremony is shown at the Merchant Mills on June 14, 1918. (Courtesy of Calumet Regional Archives.)

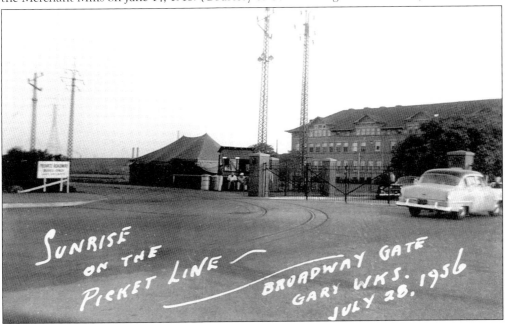

PICKET LINE, 1956. In 1956, the United Steelworkers of America flexed its collective union muscle and achieved a number of concessions from U.S. Steel, including a new contract and a substantial wage increase. The strike, which lasted 34 days, took place during the summer. When not on the picket lines, many workers who lived in the Horace Mann area made good use of the time. Some took short family vacations, while others took care of needed repairs. Many husbands called that "honey-do vacations." The photograph, titled *Sunrise on the Picket Line,* shows strikers outside the Broadway gate. (Courtesy of Calumet Regional Archives.)

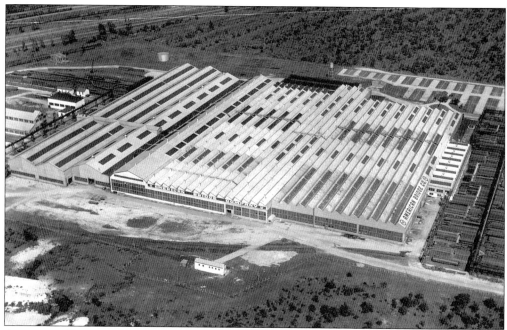

AMERICAN BRIDGE, 1950. In 1909, the American Bridge Company began operations at the western end of the U.S. Steel property. There structural steel that was used for buildings and bridges was stored, then shipped. Steel used for the Sears Tower, John Hancock Building, and the Picasso structure in the Daley Center in Chicago came from the Gary plant. Pictured is an aerial view of the facility in 1950. (Courtesy of Calumet Regional Archives.)

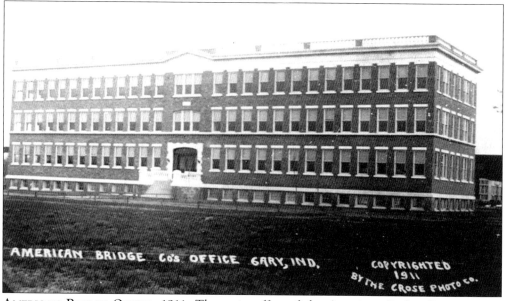

AMERICAN BRIDGE OFFICE, 1911. The main office of the American Bridge Company was built on the south side of the plant's property. There supervisors and company staff processed orders, handled finances, and organized the daily management for successful operations. The photograph was taken in 1911, and the building can still be seen from the Indiana Toll Road. (Courtesy of Calumet Regional Archives.)

44

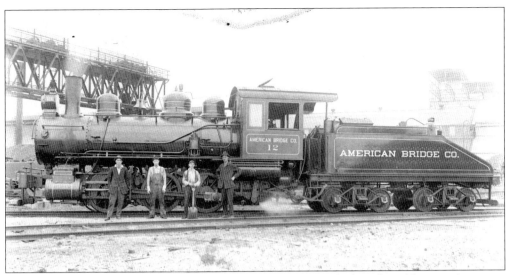

AMERICAN BRIDGE LOCOMOTIVE. To move the massive stockpiles of steel beams, American Bridge Company used their own railroad locomotives throughout the plant area. Here the crew of engine No. 12 poses for a picture on June 24, 1918. (Courtesy of Calumet Regional Archives.)

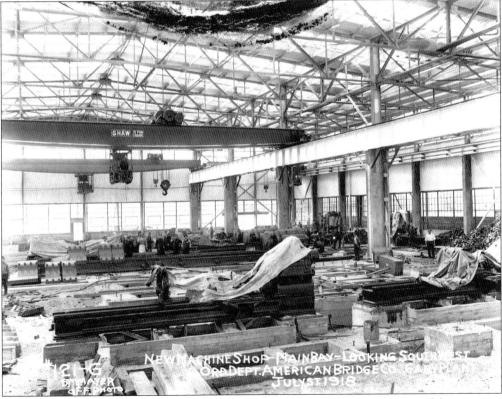

AMERICAN BRIDGE SHOP, 1918. Inside the huge shops and warehouses, steel beams were marked and arranged for assembly. Later at the job sites, the company's ironworkers constructed the towering structures, often climbing to death-defying heights. Pictured is the interior of the machine shop in 1918. (Courtesy of Calumet Regional Archives.)

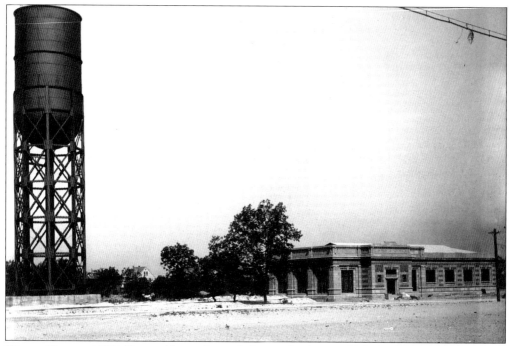

WATER TOWER, 1909. To provide much-needed water for the city, U.S. Steel created a subsidiary, the Gary Heat, Light and Water Company. A tunnel extending over a mile into the lake was connected to a pumping station located at Seventh Avenue and Jackson Street. The tower, pictured in July 1909, was constructed at what was then Jefferson Park. (Courtesy of Calumet Regional Archives.)

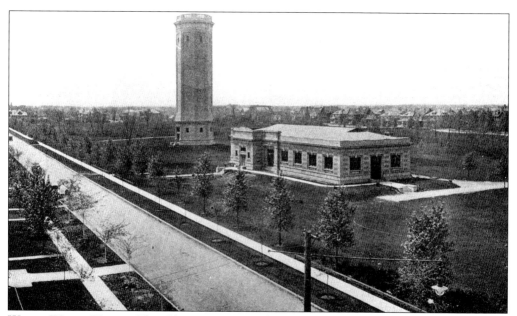

WHITE WATER TOWER. The old water tower was later covered with a concrete shell. The white structure still stands, towering over the pumping station in what is today Borman Park. (Courtesy of Calumet Regional Archives.)

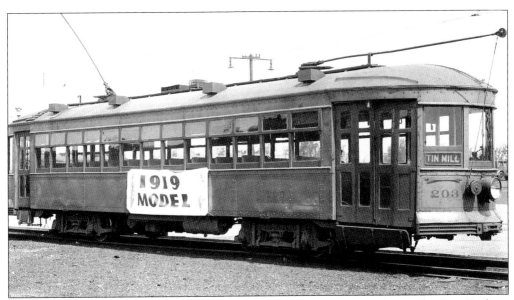

LAST TROLLEY. On February 28, 1947, the city's last trolley made its final run. The Gary Railway Company switched to busses in the fall of 1946. Pictured is the 1919 model, which took workers from Fifth and Broadway to the Tin Mill. (Courtesy of Calumet Regional Archives.)

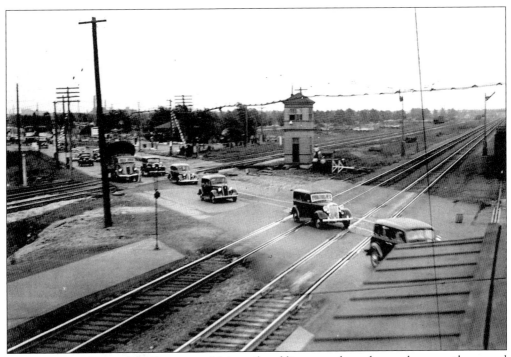

PENNSYLVANIA RAILROAD CROSSING. Major railroad lines ran along the northern, southern, and western boundaries of the Horace Mann community. They hauled essential freight and, before expressways, moved passengers throughout the region and across the nation. Traffic is shown moving west along Fifth Avenue near the Pennsylvania Railroad station in the 1930s. The tracks ran along the western edge of the neighborhood. (Courtesy of Calumet Regional Archives.)

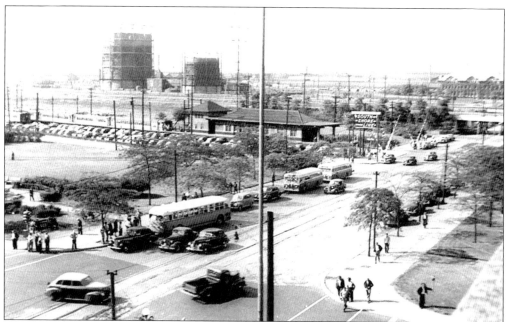

OLD GAS TOWERS, 1946. For many years, gas towers were part of the urban skyline throughout the United States. Until the Northern Indiana Public Service Company took over natural gas and electric operations throughout northern Indiana, U.S. Steel provided natural gas for the city. The towers were just west of Broadway and were torn down years ago. The old South Shore station is also visible in the 1946 photograph. (Courtesy of Calumet Regional Archives.)

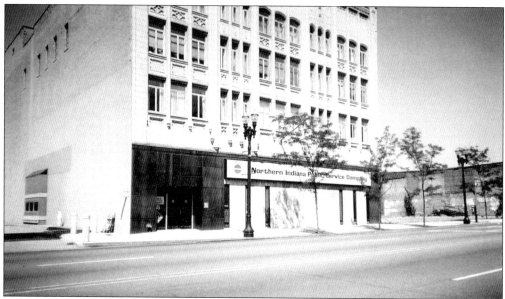

NORTHERN INDIANA PUBLIC SERVICE COMPANY OFFICE, 2005. Gary's downtown skyline has undergone tremendous change over the last 30 years. Many of the classic old buildings that housed stores and offices were torn down. The Northern Indiana Public Service Company office building, located on the 800 block of Broadway, was renovated and is still in use. It is shown in the summer of 2005. (Courtesy of Calumet Regional Archives.)

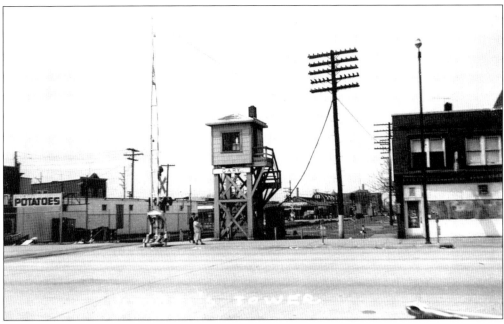

WABASH RAILROAD TOWER, 1956. Before railroad-crossing gates were put on automatic systems, workers raised and lowered them from towers that were located along the major streets in many cities and towns. For many years, one such tower stood along the Wabash Railroad tracks on Broadway. Vitucci's Tower, as it was sometimes called, was torn down after the line went out of business. It is shown here on the west side of the street in 1956. (Courtesy of Calumet Regional Archives.)

SOUTH SHORE LINE
BOOKLET. The South Shore Railroad, a long familiar sight to residents of the Calumet Region, continues to run along the north side of the Horace Mann area. Though the old orange cars have been phased out, the line continues to serve commuters. The old 1920s schedule advertises parlor and dining car service on the high-speed electric trains. (Courtesy of Calumet Regional Archives.)

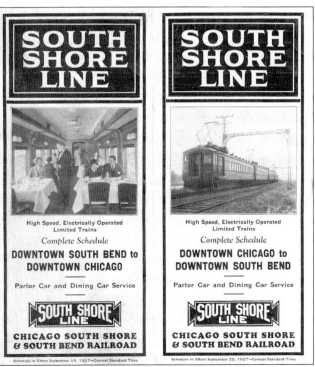

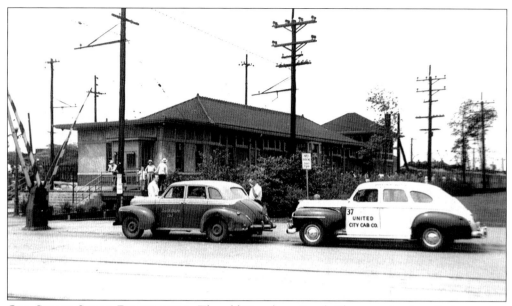

OLD SOUTH SHORE DEPOT, 1946. The old Broadway South Shore station handled countless numbers of commuters who traveled to Chicago to work or special events every day. It even had a dining area to better serve passengers. The picture, taken in 1946, shows cabs waiting to transport people to their final destinations in Gary. (Courtesy of Calumet Regional Archives.)

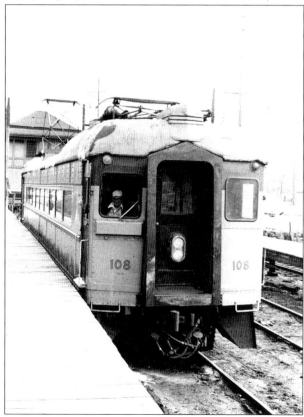

SOUTH SHORE CAR 108. Car 108 gets ready to leave the old South Shore Depot at Broadway in the early 1980s. The orange cars were replaced with a modern fleet thanks to mass transit funds from Uncle Sam. A few of the old cars still remain and sit as museum pieces. (Courtesy of Calumet Regional Archives.)

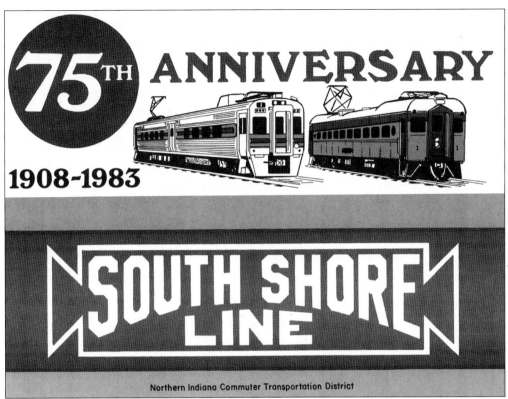

SOUTH SHORE'S 75TH YEAR. In 1983, the South Shore Railroad celebrated 75 years of continued service to the commuters of northern Indiana. Created by Samuel Insull, the interurban line linked Indiana communities as far east as South Bend with downtown Chicago. The advertisement shows the sleek new cars on the left that replaced the old orange carriers to the right. (Courtesy of Calumet Regional Archives.)

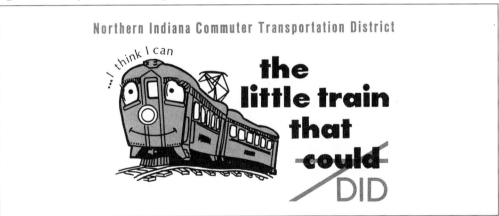

1983 SOUTH SHORE CARTOON. With its aging fleet of passenger cars and financial problems, the South Shore Railroad began a campaign to save the line. Thousands of commuters depended on the orange trains to get to work in Chicago. Eventually the railroad's passenger service was taken over by the Northern Indiana Commuter Transportation District. The 1983 picture of "the little train that could" was part of the promotional campaign to save the line. It is now the train that did. (Courtesy of Calumet Regional Archives.)

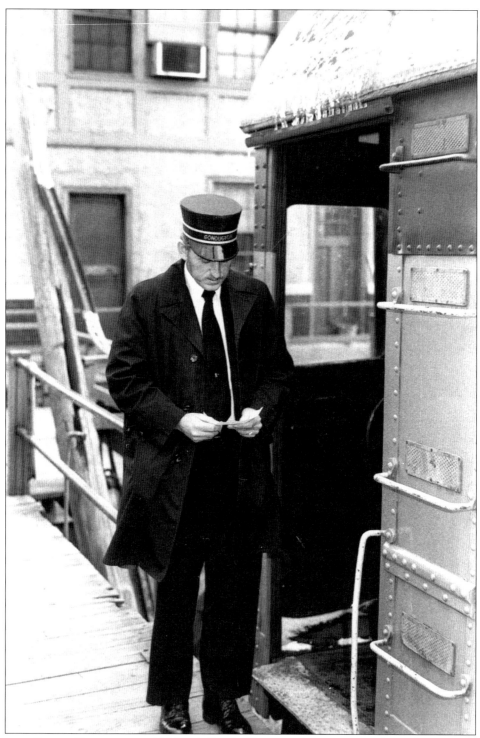

SOUTH SHORE CONDUCTOR, 1980S. A South Shore conductor gets ready to depart west for Chicago in the 1980s. Though the entire passenger fleet has been modernized, longtime commuters still have fond memories of the old orange cars. (Courtesy of Calumet Regional Archives.)

Three

LOCAL BUSINESS

Broadway was the main commercial strip in Gary and was the dividing line between the Horace Mann and Emerson neighborhoods. People shopped at major stores such as Sears, Goldblatts, J. C. Penney's, and Richman Brothers. Other downtown stores included Lyttons, Comay's, Moskins, W. T. Grant, L. Fish, and Radigan's. Dozens of smaller stores from Fourth Avenue through Eighth Avenue appealed to a variety of shoppers.

West of Broadway, Horace Mann residents and people from throughout the area patronized Gary Camera, Bud Pressner's, Rod Gross Sports, Olsen Cadillac, and Townsend Pontiac. They dined at the Lighthouse, Walts, and the Blackstone Grill. Many enjoyed the sandwiches from Lincoln Carry Out as well as the dishes at the Tivoli Tap. For the over-21 crowds there were the Crystal Tap, Ingot Saloon, and other corner watering holes. Three theaters, long gone, were the Tivoli, the State, and the Fifth Avenue.

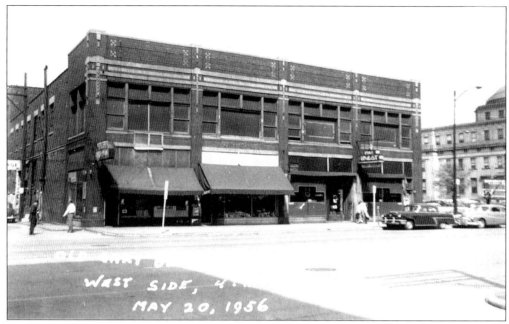

INGOT SALOON. An important gathering place for many men in the Steel City was the neighborhood saloon. The Ingot Saloon was located in the 400 block of Broadway, just a few blocks south of the main gate of U.S. Steel's Gary Works. Located in the old Gary Building, it was named for the massive steel castings, made in the Open Hearth Plant, called ingots. The tavern is pictured in 1956. (Courtesy of Calumet Regional Archives.)

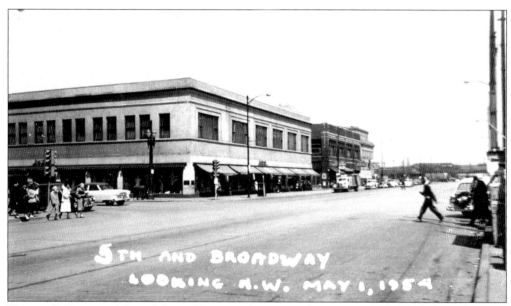

HENRY C. LYTTON. Many fashionable stores for men and women were located along the city's main business strip, Broadway. Henry C. Lytton and Sons was a classy men's store that carried some of the finest major brand names in apparel. Shown here in 1954, it was located on the northwest corner of Fifth Avenue and Broadway. It was torn down around 1970. (Courtesy of Calumet Regional Archives.)

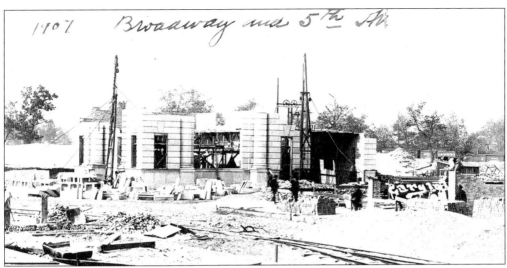

GARY STATE BANK, 1907. When U.S. Steel's Gary Works began operations, no banking firms conducted business in the city. Money for the paymaster's office was held in a special vault of the plant's main office. In 1907, the first Gary State Bank building was built on the southwest corner of Fifth Avenue and Broadway. For many workers, though, local saloons had adequate funds to cash checks and even held their customers' money for safekeeping. (Courtesy of Calumet Regional Archives.)

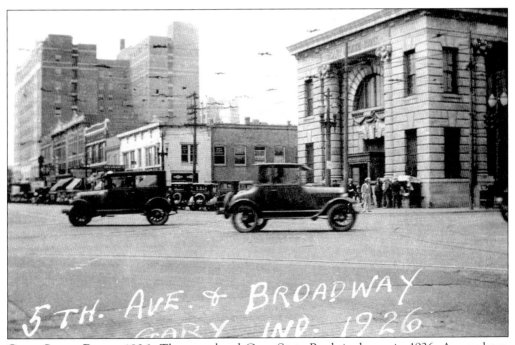

GARY STATE BANK, 1926. The completed Gary State Bank is shown in 1926. A year later, the structure was torn down and replaced with a new building that housed the bank and its operations as well as professional offices for doctors, lawyers, and accounting firms. At left is the Gary Hotel. (Courtesy of Calumet Regional Archives.)

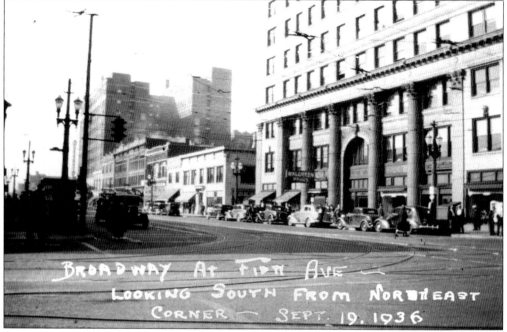

GARY STATE BANK, 1936. By September 1936, the corner of Fifth Avenue and Broadway underwent major change. The original Gary State Bank was replaced by a new 10-story structure. Still in operation, the bank has seen a number of name changes. In 2005, Bank One was in the process of a merger with J. P. Morgan Chase. (Courtesy of Calumet Regional Archives.)

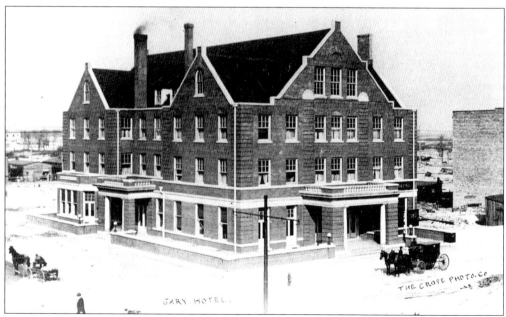

ORIGINAL HOTEL GARY, 1907. One year after the founding of Gary, the city's first major hotel was open for business. Pictured here around 1907, the original Hotel Gary was on the northwest corner of Sixth Avenue and Broadway. (Courtesy of Calumet Regional Archives.)

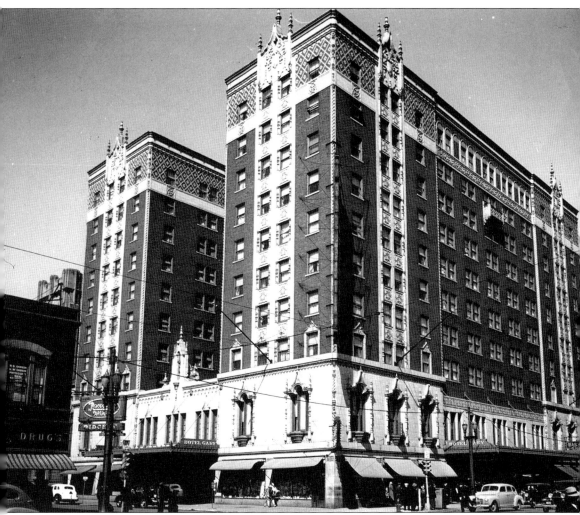

HOTEL GARY, 1940S. A much larger Hotel Gary replaced the original structure during the mid-1920s. The hotel, pictured in the 1940s, became a seniors' home, and the name was changed to the Genesis Towers. (Courtesy of Calumet Regional Archives.)

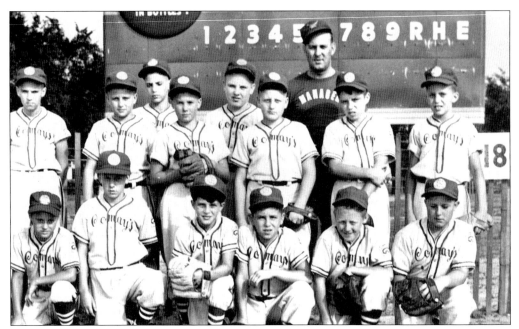

LITTLE LEAGUE TEAM, 1953. After World War II, boys throughout Gary, as well as across the nation, took part in Little League baseball. Local business establishments in the Steel City sponsored teams while adults gave their time to coach and teach fundamentals. The free advertisement was also good for business. Pictured is the team from Comay's Jewelers at the Jackson Park Little League in 1953. The coach is Glen Hoffman. (Courtesy of Don Mueller.)

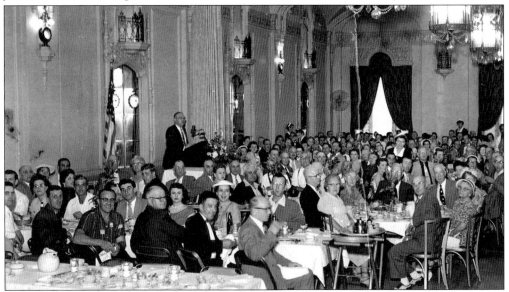

HOTEL GARY DINING ROOM, 1950. Hotel Gary played host to many prominent individuals, including political figures such as Pres. Harry Truman, Sen. John F. Kennedy (when he was the 1960 Democratic nominee), and Ronald Reagan (while governor of California). The building's halls and dining areas held elegant dinners, school turnabouts, political luncheons, and wedding receptions. The crowd is shown in the Hotel Gary Dining Room in 1950. (Courtesy of Calumet Regional Archives.)

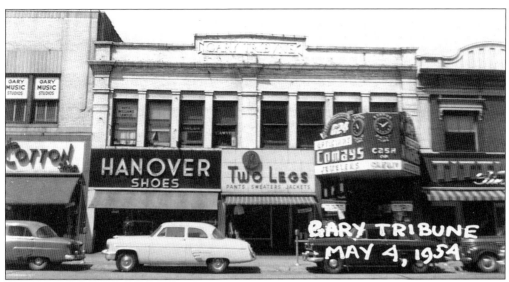

COMAY'S JEWELERS, 1954. For many years, Comay's Jewelers was a well-known business throughout the Calumet Region. Diamonds, jewelry, engagement rings, and other precious stones could be purchased there for reasonable prices. During the 1950s and 1960s, the latest and most popular 45-rpm records or albums could be listened to in special booths and then purchased. In the mid-1950s, Comay's shared the former Gary Tribune Building with Hanover Shoes and Two Legs. (Courtesy of Calumet Regional Archives.)

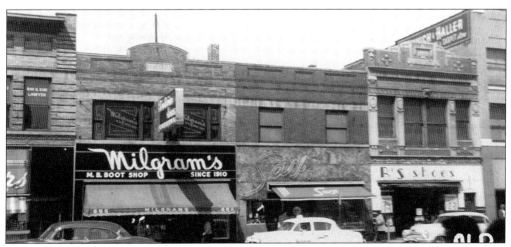

MILGRAM'S SHOES, 1954. Milgram's Shoes was located at 686 Broadway, on the west side of the street in 1954. Downtown business was booming in the 1950s, as indoor shopping malls were rare in the United States. (Courtesy of Calumet Regional Archives.)

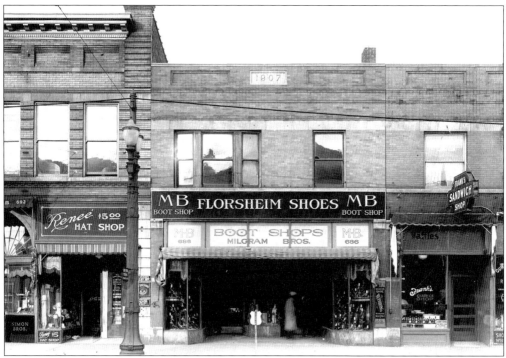

FLORSHEIM SHOES, 1927. Twenty-seven years earlier, the same owners operated the business but under the Florsheim Shoes banner. The building on the west side of Broadway was the first downtown brick structure constructed in 1907. When it opened that year, it was Morris Kahan's General Merchandise Store. (Courtesy of Calumet Regional Archives.)

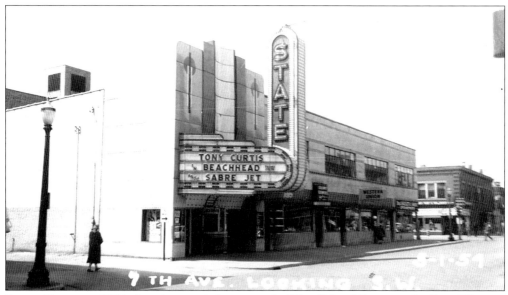

STATE THEATER, 1954. Another movie house on the West Side of Gary was the State Theater, located on Seventh Avenue and Washington Street. In this 1954 picture, the sign atop the marquee, "its Cool inside" advertising the air-conditioning, was not yet in place. The structure was originally called the Kahn Building. (Courtesy of Calumet Regional Archives.)

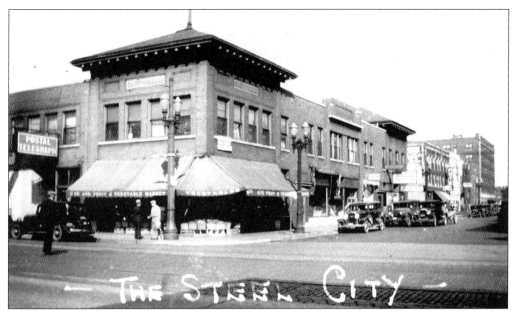

Fifth Avenue Fruit Market, 1934. With the local economy moving at a snail's pace in the early 1930s, small businesses were hard-pressed to earn a profit. Still many family ventures managed to continue through the Great Depression. Pictured here are the Fifth Avenue Fruit and Vegetable Market at 100 West Fifth Avenue in October 1934. (Courtesy of Calumet Regional Archives.)

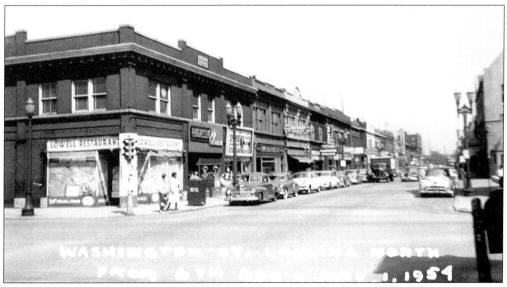

Lowell Restaurant, 1954. Washington Street, between Fourth and Ninth Avenues, contained a variety of small businesses in the 1950s. Restaurants, clothing stores, loan companies, and specialty shops were the most common. The Lowell Restaurant, at Sixth Avenue and Washington Street, catered to the downtown workers as well as the neighborhood locals. (Courtesy of Calumet Regional Archives.)

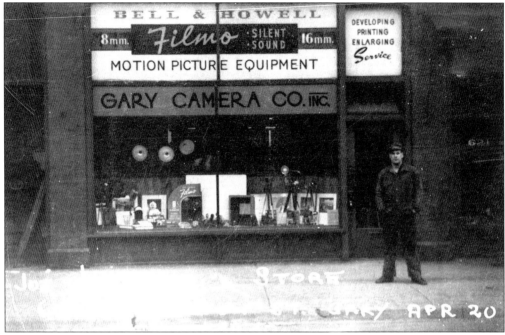

GARY CAMERA, 1940. Gary Camera Company provided a wide assortment of cameras and photography equipment as well as needed services. The business, located at 619 Washington Street, is shown in 1940. The business is still in operation in Merrillville, Indiana. (Courtesy of Calumet Regional Archives.)

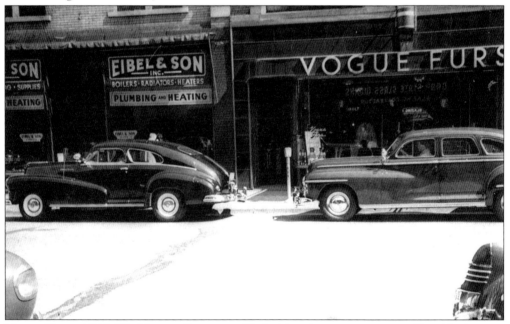

VOGUE FURS, 1946. Washington Street was filled with a diverse assortment of local businesses. Clothing and hardware stores stood alongside specialty shops and saloons. Here Vogue Furs was located next to Eibel and Son Plumbing in 1946. Notice the classic, American-made cars. (Courtesy of Calumet Regional Archives.)

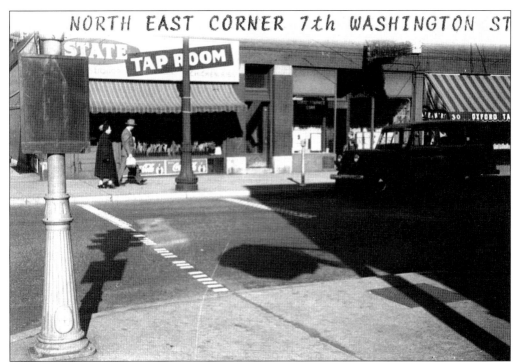

STATE TAP ROOM, 1946. Most of the drinking establishments along Washington and Adams Streets did not appeal to the fine-dining crowd. They were blue collar, shot and beer places that served as a second home to the local mill workers. Lunch and dinner were available, but from a limited menu. Pictured is the State Tap Room in 1946. (Courtesy of Calumet Regional Archives.)

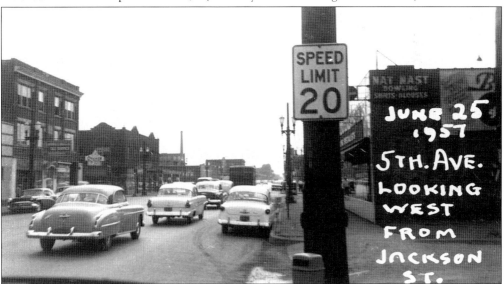

FIFTH AVENUE AND JACKSON, 1957. In the 1950s, Gary's traffic control system was geared for fewer cars and slower speeds. Nearly all of the city's streets handled two-way traffic, but as more residents purchased automobiles, congestion was common. After the traffic study of 1956 was completed, most city streets were changed to handle one-way movement. In this picture, Fifth Avenue was still a two-way commercial street. (Courtesy of Calumet Regional Archives.)

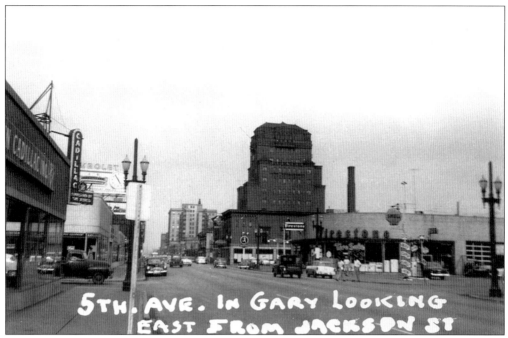

FIFTH AND JACKSON, LOOKING EAST, 1957. The post–World War II economy continued to expand well into the 1960s in Gary and around the nation. Along West Fifth Avenue, business was brisk in 1957. Olsen Cadillac can be seen at the left while the Firestone Tire center is visible at right. Olsen's later moved to the Miller section of Gary. (Courtesy of Calumet Regional Archives.)

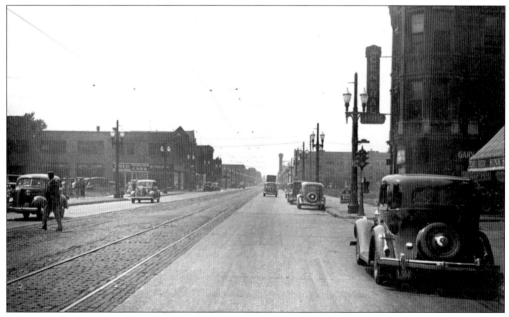

FIFTH AND MADISON, 1936. West Fifth Avenue, like Broadway, continued to show signs of steady recovery in the late 1930s. At left a used car lot offers bargains while on the right General Tire is open for business. The tire store relocated and the building later housed the Blackstone Grill. (Courtesy of Calumet Regional Archives.)

AMBASSADOR LANES, 1964. Bowling became quite popular in the Steel City for men and women of all age groups in the 1950s and 1960s. A number of leagues were formed and they competed throughout the Calumet Region. Local businesses, lodges, or industrial unions sponsored most bowling leagues. A 1964 advertisement for the Ambassador Lanes, located at 523 West Fifth Avenue, is shown. (Courtesy of Calumet Regional Archives.)

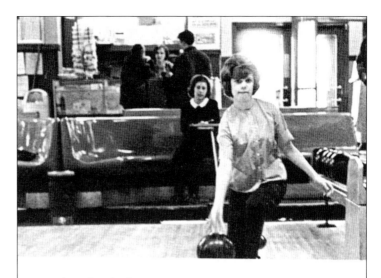

Judy Altenhof and Maria Sarich enjoy bowling.

AMBASSADOR LANES

523 W. 5th Ave.

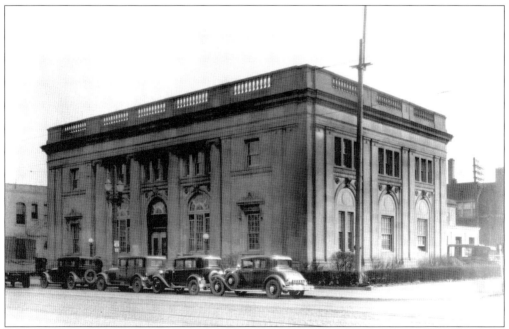

ZALE'S BOWLING ALLEY. Another bowling alley operated at Fifth Avenue and Adams Street on the city's West Side. When it was first constructed, it housed the main post office. Later the brother of boxing champion Tony Zale purchased the building and opened a bowling alley. Shown here in February 1931, the structure was torn down to make way for a bank. (Courtesy of Calumet Regional Archives.)

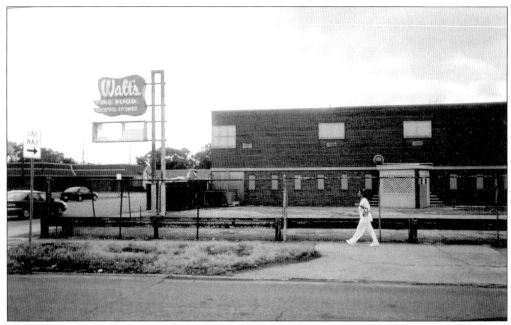

WALT'S RESTAURANT, 2005. Walt's, located a few blocks west of Broadway, provided great food for an array of dining occasions. It catered to the evening dinner crowd as well as the large lunchtime clientele from local businesses and office workers. The business, owned by Walter Bobruk, closed in the late 1970s. (Courtesy of John C. Trafny.)

THE LIGHTHOUSE, 2005. Just east of Walt's, the building that once housed the Lighthouse still stands. The restaurant provided fine dining in an elegant and intimate atmosphere. Local business and political groups often held lunches or dinners there. For young couples, it was the place to go for that special evening. It is pictured in the summer of 2005. (Courtesy of John C. Trafny.)

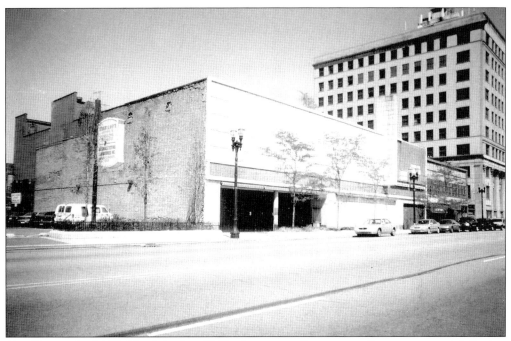

OLD PENNEY'S, 2005. Until the late 1960s, downtown Gary was a vibrant commercial district, attracting shoppers from throughout the region. For many residents of the Horace Mann district, it was also convenient since they lived within walking distance of Broadway. But with suburban malls, crime, and the downturn of the steel industry, many businesses relocated or closed forever. Pictured is the old J. C. Penney's store near Fifth and Broadway, closed, and a memory of another era. (Courtesy of John C. Trafny.)

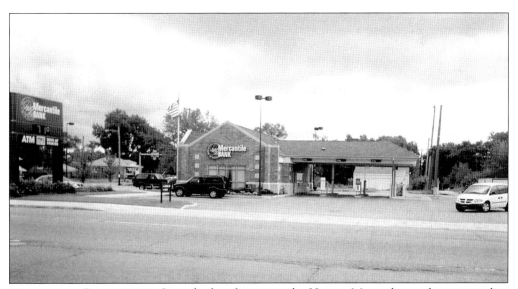

MERCANTILE BANK, 2005. Over the last few years, the Horace Mann district has seen a slow but steady business revival. With new housing going up just west of Broadway, business owners have shown renewed interest to invest, especially along West Fifth Avenue. Pictured is the Mercantile Bank across from Firehouse No. 8. (Courtesy of John C. Trafny.)

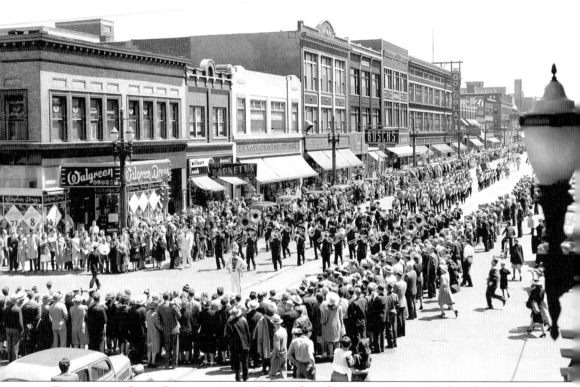

DOWNTOWN GARY PARADE, 1940S. Pictured is the Horace Mann High School Band on parade at Sixth Avenue and Broadway in the 1940s. Old-timers will fondly recall that crowds were often five and six deep along parade routes. For those too young to know, the photograph should provide a better understanding of just how prosperous and full of life Broadway once was. (Courtesy of Calumet Regional Archives.)

Four

HOUSES OF WORSHIP AND FAITH-BASED ORGANIZATIONS

There were many houses of worship in the Horace Mann neighborhood where people of many faiths assembled as a community in common prayer. People sent their children there for religious instruction and sought spiritual help and guidance in time of need. Families and friends gathered together for baptisms, first communions, bar mitzvahs, weddings, and funerals. Protestants, Catholics, and Jews observed the Sabbath and holy days, celebrated weddings or the entry into adulthood, and mourned the passing of a family member or friend.

The congregation raised the money for the building, and many put their time and effort into the actual construction. Each building displayed a unique architectural style, from the grand and majestic to the very simple. All served as the spiritual meeting place where each denomination could share its faith.

Two hospitals were established on the West Side to care for the sick and infirm and both cared for people of all faiths. In addition, religious groups were involved with social and fraternal societies and often sponsored scout packs, summer camps, and sporting clubs for the young.

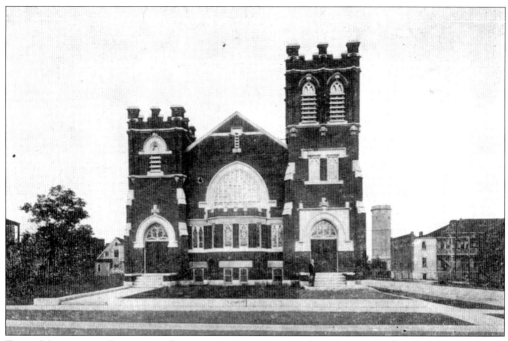

FIRST METHODIST EPISCOPAL CHURCH, 1912. In 1912, the First Methodist Episcopal Church was built at Seventh Avenue and Adams Street. The building was sold to a mortuary when the new City church was built. Later the Loyal Order of Moose purchased the building. Though the structure is long gone, the surrounding area has undergone a revival with new home construction in 2005. (Courtesy of Calumet Regional Archives.)

CONGREGATIONAL CHURCH. Gary's First Congregational Church was constructed in the 600 block of Madison in the early 20th century. Today it is home to the River of Life Church. It is shown in July 2005. (Courtesy of John C. Trafny.)

TEMPLE BETH EL, 1960S. For years, many families of the Jewish faith in the Horace Mann neighborhood worshiped at the Temple Beth El, located on West Fifth Avenue. The temple is shown here in the 1960s. (Courtesy of Calumet Regional Archives.)

BETHLEHEM HEALING TEMPLE, 2005. Today the congregation of the Bethlehem Healing Temple holds services at 700 Jefferson Street. Years ago it was home to the Central Christian Church. It is pictured in 2005. (Courtesy of John C. Trafny.)

FIRST BAPTIST CHURCH. Members of the Crossroads Missionary Baptist Church now hold their worship services at 529 Jefferson Street. The church, shown in 2005, was once the First Baptist Church of Gary. (Courtesy of John C. Trafny.)

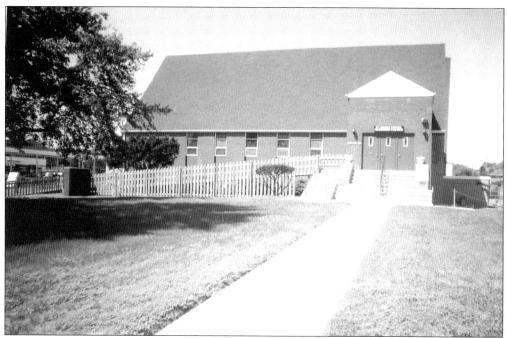

FIFTH AVENUE UNITED METHODIST. The Fifth Avenue United Methodist Church was photographed in July 2005. The east side of the church, located at 2600 West Fifth Avenue, is shown. (Courtesy of John C. Trafny.)

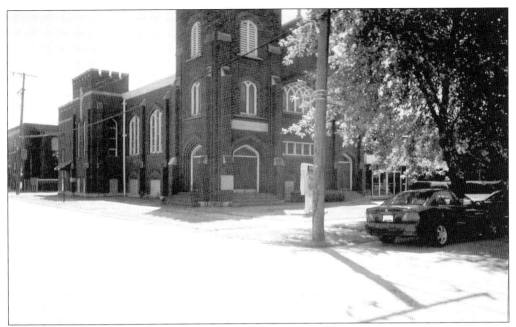

BETHLEHEM LUTHERAN CHURCH, 2005. The main entrance of the Bethlehem Lutheran Church was photographed in the summer of 2005. Church members meet for services at 601 Fillmore Street. (Courtesy of John C. Trafny.)

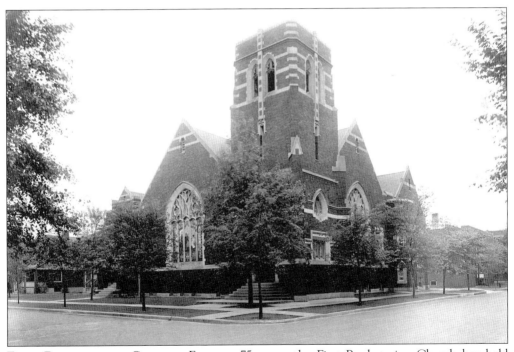

FIRST PRESBYTERIAN CHURCH. For over 75 years, the First Presbyterian Church has held worship service at 574 Monroe Street. The church, pictured here, stands just across the street from the vacant Ambassador Apartments. In the late summer of 2005, the small congregation voted to dissolve and sell the building. (Courtesy of Dr. Warren E. Johnson.)

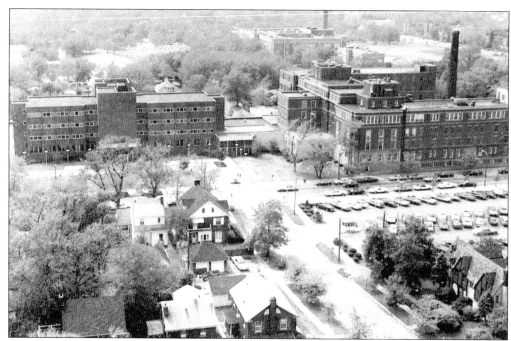

METHODIST HOSPITAL, 1980. Methodist Hospital, located in the 600 block of Grant Street, has served the area since the mid-1920s. This aerial shot of the Northlake Campus was taken around 1980. The new addition is visible at left, while Horace Mann High School can be seen in the background. (Courtesy of Calumet Regional Archives.)

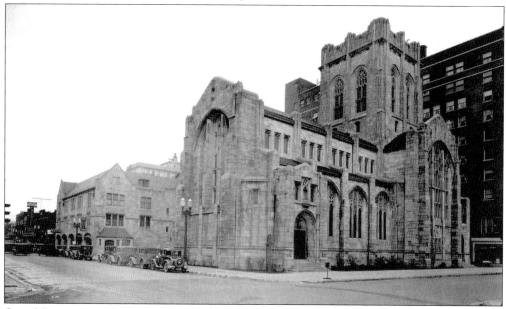

CITY METHODIST, 1920s. City Methodist Church, located at the intersection of Sixth Avenue and Washington Street, was dedicated on October 10, 1926. The magnificent Gothic structure was the grand dream of Dr. William Grant Seaman. When it was completed, the facility contained the main worship area, a commercial wing, and an educational center. Today the old structure stands abandoned and neglected. (Courtesy of Calumet Regional Archives.)

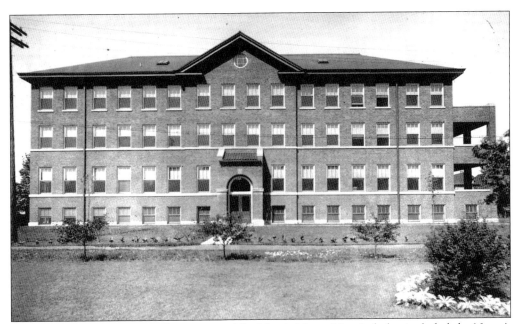

NURSE'S BUILDING, 1924. The campus of St. Mary's Mercy Hospital also included the Nurse's building, located at 540 Tyler Street. The dormitory provided housing for nurses and students. The building is shown in August 1924. (Courtesy of Calumet Regional Archives.)

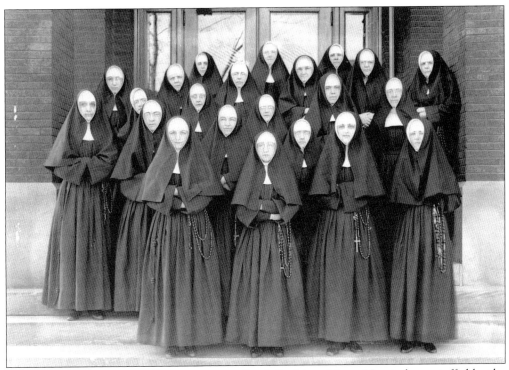

POOR HANDMAIDS, 1922. For many years, Gary's St. Mary Mercy Hospital was staffed by the Sisters of the Poor Handmaids. The sisters and Mother Superior pose for a group photograph in February 1922. (Courtesy of Calumet Regional Archives.)

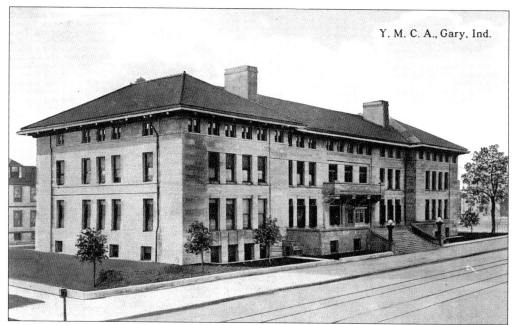

OLD YMCA. Gary's original YMCA building was located at the intersection of Fifth Avenue and Jefferson Street. The lot was donated by the Gary Land Company. In the 1960s, the structure was razed and a new building went up at that same location. (Courtesy of Calumet Regional Archives.)

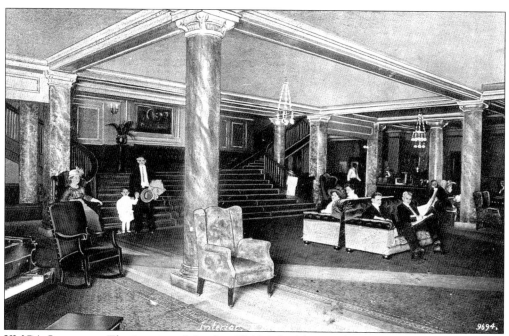

YMCA INTERIOR. The interior of the first YMCA building included an elegant and spacious lobby where guests could relax and visit. The photograph was taken about 1920 and became part of a postcard series of Gary. (Courtesy of Calumet Regional Archives.)

Five

HOLY ANGELS

When the city of Gary was incorporated in 1906, the Diocese of Fort Wayne, Indiana, established Holy Angels Parish at Sixth Avenue and Tyler Street. The young steel town's population was growing rapidly as a steady flow of new workers found employment in the mills, brought their families, and established permanent roots. Many were Roman Catholic, so the diocese consecrated the new church to meet their needs and a school to educate their children. The Rev. Thomas F. Jansen was appointed the first pastor of the parish.

The Sisters of Notre Dame made up the teaching staff of the school for many years. Classes were large, sometimes over 40 students, with only one nun in charge. Discipline was maintained and few students dared to cross the line. If the student was punished at school, he did not dare complain to his parents. Imagine a student whining to the old man after he just finished a hard day at the mill at the Open Hearth or Blast Furnace Department.

Contrary to popular Hollywood myth, the vast majority of nuns were dedicated teachers who cared about the students and wanted them to be prepared for life. And most graduates appreciated the efforts.

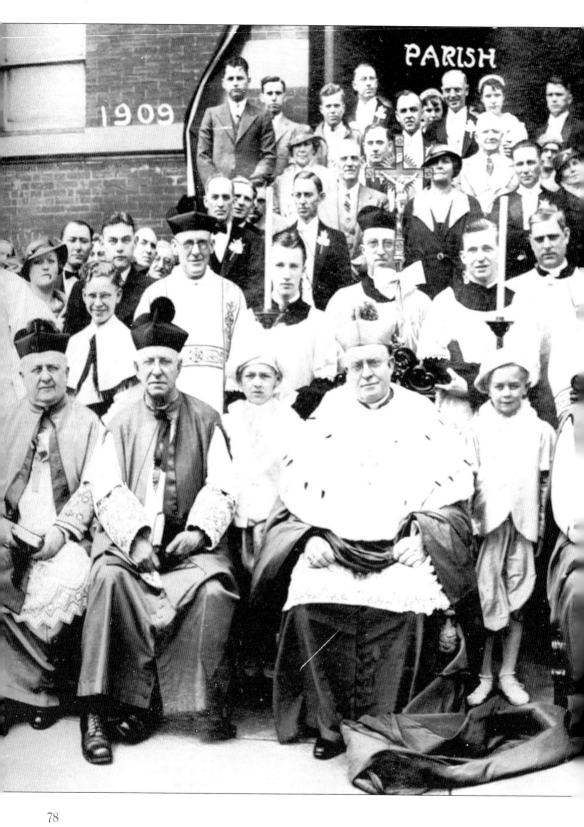

HOLY ANGELS, 1931. In 1931, Holy Angels Parish observed its silver jubilee. Pictured are the parishioners, the pastor, Father Thomas F. Jansen, and the bishop of the Diocese of Fort Wayne, the Most Reverend John Frances Noll. The photograph was taken outside the main entrance of the old church and school building. (Courtesy of Holy Angels.)

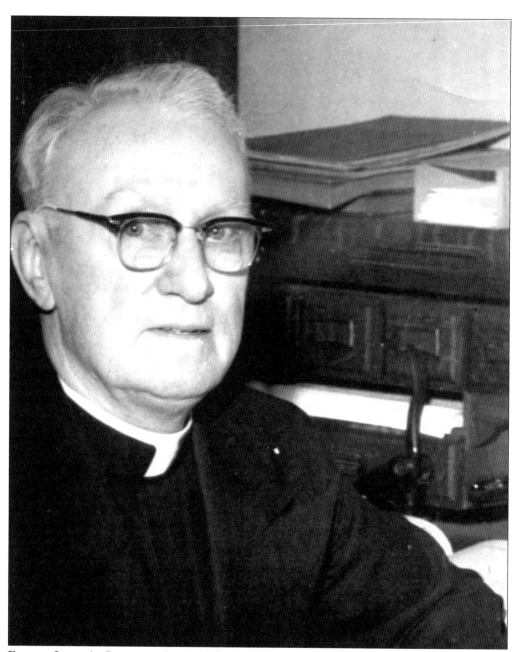

FATHER JOHN A. SULLIVAN. In 1942, the Rev. John A. Sullivan was appointed pastor of Holy Angels Parish by the bishop of the Diocese of Fort Wayne. For more than two decades, Father Sullivan ran the parish church, managed the finances, and maintained a strong student enrollment of Holy Angels School. He is pictured here in the late 1950s. (Courtesy of Don Mueller.)

JOHN CAMPBELL, 1944. During World War II, families with loved ones serving in the armed forces displayed red, white, and blue flags with stars in their windows. Each star represented a family member in the military. A blue star stood for those on active duty while a gold star honored those who gave their lives in the cause for freedom. John Campbell, at the 600 block of Garfield Street, stands before his house. Tom, his son, is seen in the window in 1944. (Courtesy of Tom Campbell.)

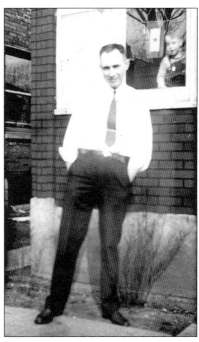

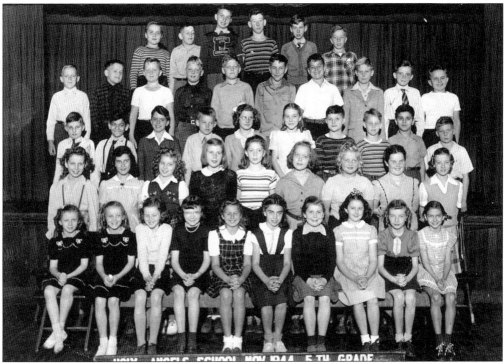

FIFTH-GRADE CLASS, 1944. While American forces were involved in the greatest war in history, parish and school life went on, but with prayer and sacrifice. Pictured is the fifth-grade class of Holy Angels in November 1944. In Europe, one of the biggest battles of the war would soon begin, the Battle of the Bulge. It was quite possible that loved ones of this group were taking part. (Courtesy of Tom Campbell.)

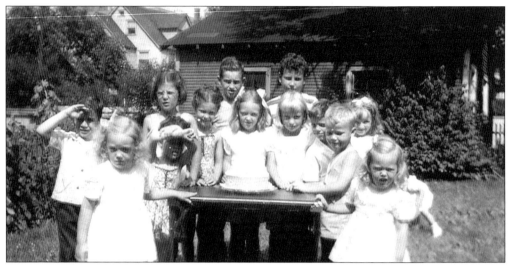

BIRTHDAY PARTY, 1947. For children, life got back to normal rather quickly after World War II. They enjoyed being kids, playing, and having fun. In 1947, the neighborhood youngsters in the 600 block of Garfield Street enjoy a birthday party Fred Edwards gave for his daughter Yvonne. (Courtesy of Tom Campbell.)

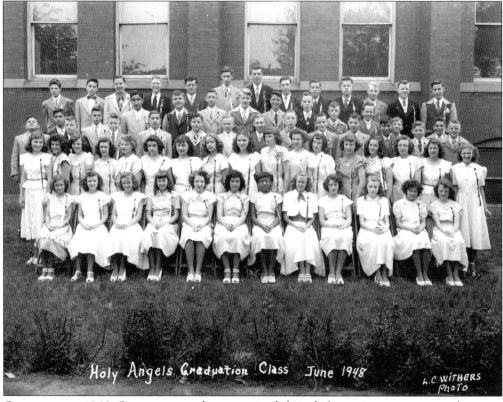

GRADUATION, 1948. Sixty-seven graduates received their diplomas in a ceremony and mass at Holy Angels Parish in June 1948. The group is pictured outside of the school building. (Courtesy of Tom Campbell.)

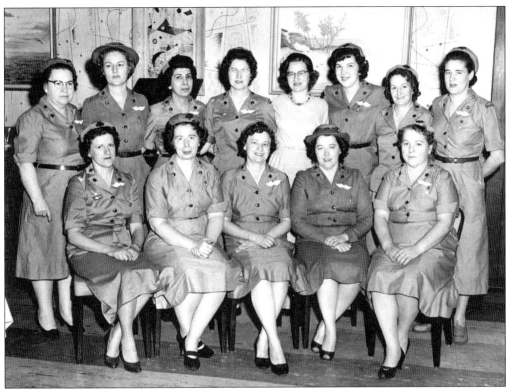

GIRL SCOUT LEADERS. Many children from the parish joined either the Boy Scouts or the Girl Scouts. Parents also volunteered their time to serve as leaders. Pictured are the ladies who served as Girl Scout leaders during their 25th anniversary at Holy Angels. (Courtesy of Holy Angels.)

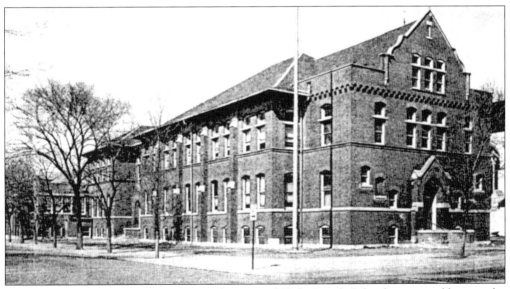

FIRST HOLY ANGELS SCHOOL, 1950s. The original Holy Angels School is pictured here in the 1950s. With a growing student population, the old school was torn down and a new building and gym were built northwest of the cathedral in the 1960s. (Courtesy of Don Mueller.)

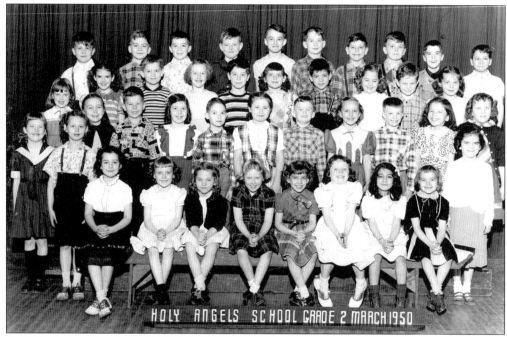

SECOND GRADE, 1950. The second-grade class of Holy Angels School is shown in March 1950. (Courtesy of Tom Campbell.)

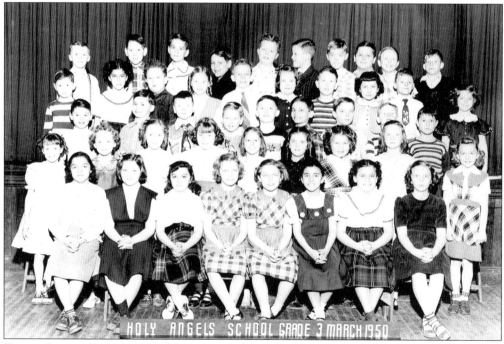

THIRD-GRADE CLASS, 1950. Class pictures bring back many fond memories, some comical. The fifth student from the right in the top row seemed to be more interested in carrying on a conversation with his friend than looking at the camera. Pictured is the third-grade class in March 1950. (Courtesy of Don Mueller.)

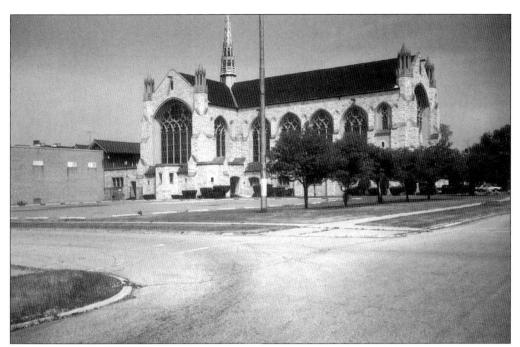

HOLY ANGELS CATHEDRAL, 1950S. In January 1950, Holy Angels Church, located at 640 Tyler Street, was dedicated. Seven years later, it became the cathedral for the new Diocese of Gary after the consecration of the Most Reverend Andrew G. Grutka as the first bishop. The structure underwent an extensive interior and exterior renovation in the 1990s. (Courtesy of Calumet Regional Archives.)

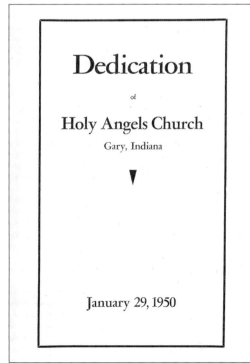

Dedication

of

Holy Angels Church

Gary, Indiana

▼

January 29, 1950

HOLY ANGELS DEDICATION BOOKLET. Pictured is the program booklet that was given to the members of the parish and visitors for the dedication that took place on January 29, 1950. (Courtesy of Calumet Regional Archives.)

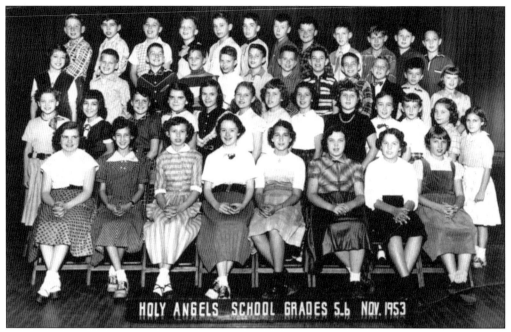

FIFTH AND SIXTH GRADES, 1953. The combined fifth- and sixth-grade class of Holy Angels is pictured here in 1953. (Courtesy of Tom Campbell.)

SEVENTH-GRADE CLASS, 1953. A generation ago, large classes were quite common, yet the nuns managed to keep order and maintain discipline. Of course, most students did not dare tell mom and dad that they were punished for goofing off in class. They knew the consequences. The members of the seventh-grade class of Holy Angels are pictured here in 1953, all 47 of them! (Courtesy of Don Mueller.)

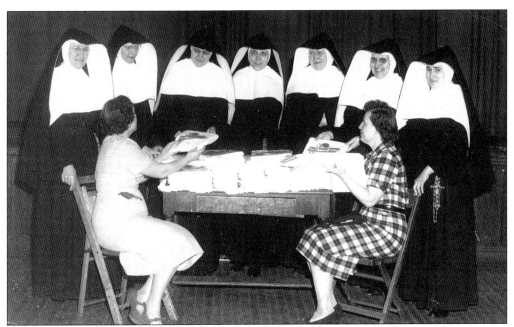

HOLY ANGELS NUNS. Years ago, nearly all Roman Catholic elementary and secondary schools were run by religious orders of nuns, brothers, or priests. At Holy Angels School, the teachers were the Sisters of Notre Dame. The sisters are pictured here receiving linen from the ladies of the archconfraternity in 1957. Today only a small number of Catholic schools are managed and staffed by a religious order, as most teachers are from the laity. (Courtesy of Don Mueller.)

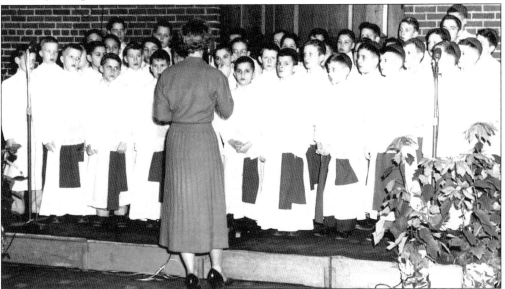

ALTAR BOYS AT CHRISTMAS. Christmas was always an enjoyable time for children but busy and hectic for merchants and shoppers. Downtown Gary stores and streets were packed with people trying to find the right gift. To help set the mood, carolers from schools and religious groups and the Goodfellow Club from U.S. Steel sang in stores, halls, and banks. Pictured are the altar boys from Holy Angels singing for guests at Memorial Auditorium in 1955. (Courtesy of Don Mueller.)

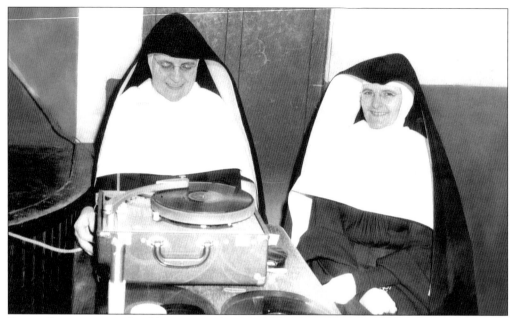

DANCE INSTRUCTORS. In addition to academics, students at Holy Angels School were encouraged to learn the social graces so they would know how to interact with others. Sister Mary Manettee, left, and Sister Mary Leonelle, right, both eighth-grade teachers, taught dance classes to the boys and girls. Couples were reminded to keep at arm's length, and no doubt a few boys were told they did not have to hold up the walls. (Courtesy of Don Mueller.)

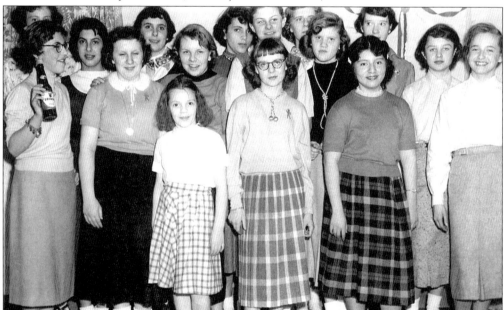

BIRTHDAY PARTY, 1955. Birthday parties were always fun and a good way to get to know classmates, even for seventh and eighth graders. The young ladies seem at ease, trying to act mature in the photograph taken in 1955. The girl on the far left is maybe trying to be too mature, holding the bottle of Drewry's beer. The picture, hopefully, never found its way home. (Courtesy of Don Mueller.)

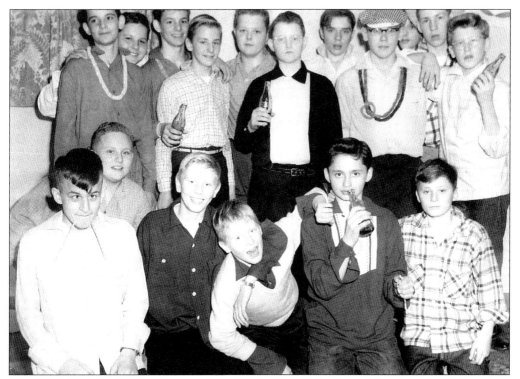

BIRTHDAY PARTY, 1955. Boys, on the other hand, will be boys. Maturity often takes time. Pictured are the guys at the same party. The young man on the left in the first row was probably trying to express himself, in his own way. (Courtesy of Don Mueller.)

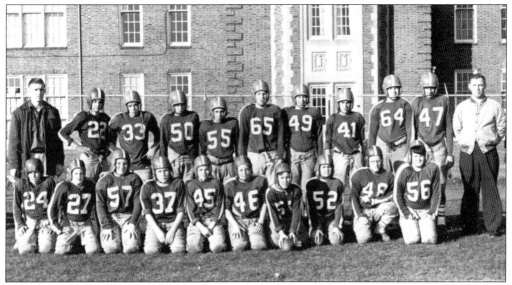

HOLY ANGELS FOOTBALL. Catholic Youth Organization sports were very popular in the Gary and suburban Catholic schools for many years. The Catholic Youth Organization sponsored the programs in a number of schools in the area. Here the Holy Angels Bears pose for their team picture at Tolleston Field in Gary in 1955. A number of the team members went on to play at either Horace Mann or at Bishop Noll Institute in Hammond. (Courtesy of Don Mueller.)

GRADUATION, 1956. The Holy Angels class of 1956, in caps and gowns, is shown with Msgr. John A. Sullivan. (Courtesy of Tom Campbell.)

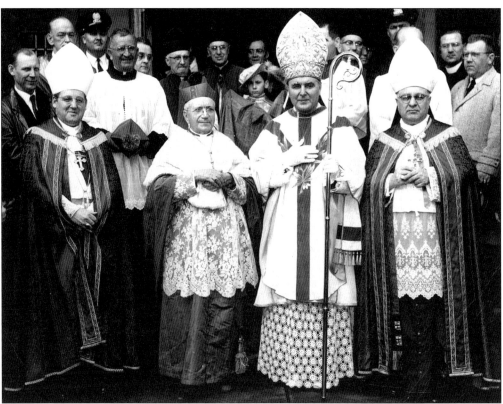

BISHOP GRUTKA INSTALLATION. The Most Reverend Andrew G. Grutka was consecrated and installed as the first bishop of the Diocese of Gary on February 25, 1957, at Holy Angels Cathedral. Bishop Grutka served as a priest in the Diocese of Fort Wayne and later the pastor of Holy Trinity in Gary. As a young man, he even worked for a time in the Open Hearth Department of U.S. Steel. (Courtesy of Calumet Regional Archives.)

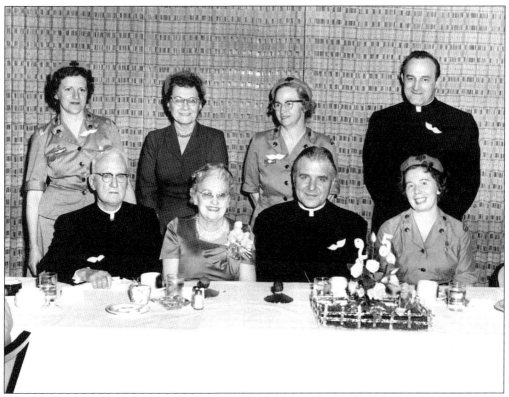

GRUTKA AND SCOUT LEADERS. Bishop Grutka sits with the Girl Scout leaders around 1960. (Courtesy of Holy Angels.)

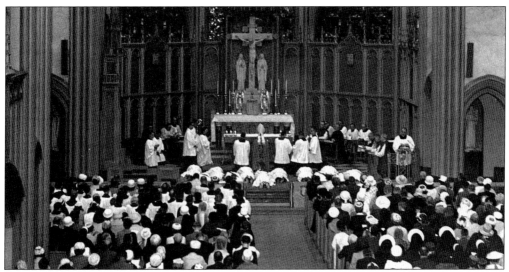

ORDINATION OF PRIESTS, 1967. In 1967, eight seminarians took their final vows and received the sacrament of holy orders. They were ordained at Holy Angels Cathedral before a large crowd of family members, friends, and guests from throughout the diocese. The Most Reverend Andrew G. Grutka, bishop of the Diocese of Gary, administered the sacred sacrament. (Courtesy of Calumet Regional Archives.)

HOLY ANGELS SCHOOL, 1980. Pictured is Holy Angels School in 1980. The view is of the east side and the parking lot on Tyler Street. (Courtesy of Calumet Regional Archives.)

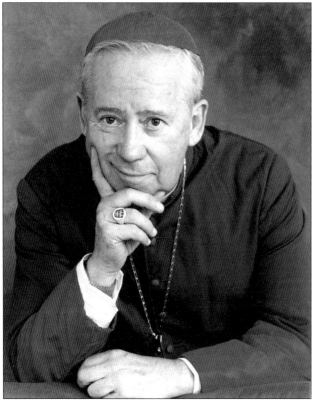

BISHOP NORBERT GAUGHN. When Bishop Grutka retired in July 1984, Pope John Paul II appointed the Most Reverend Norbert F. Gaughn as the second bishop of the Diocese of Gary. Bishop Gaughn had previously served as the auxiliary bishop of the Diocese of Greensburg, Pennsylvania. He retired in 1996 due to serious health problems following a stroke he had had years earlier. He is pictured here in the mid-1980s. (Courtesy of Calumet Regional Archives.)

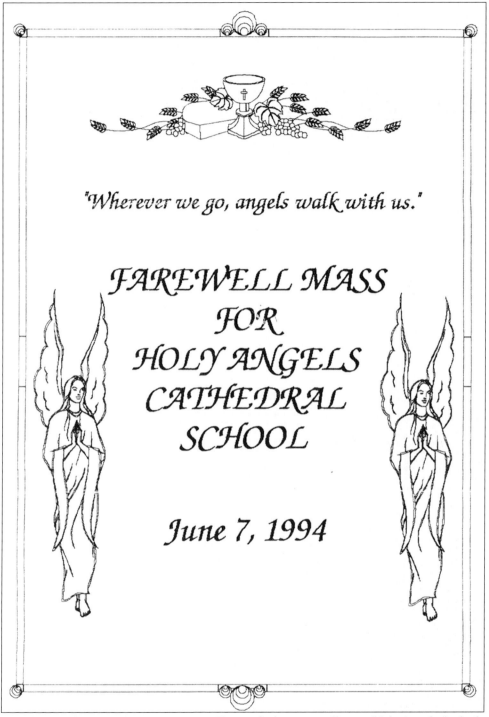

"Wherever we go, angels walk with us."

FAREWELL MASS
FOR
HOLY ANGELS
CATHEDRAL
SCHOOL

June 7, 1994

HOLY ANGELS SCHOOL FAREWELL, 1994. Due to declining enrollment, Holy Angels Cathedral School at 675 West Sixth Avenue was forced to close in 1994. It was later reopened as Sister Thea Bowman Elementary School. The cover of the program for the farewell mass celebrated on June 7, 1994, is pictured. (Courtesy of Calumet Regional Archives.)

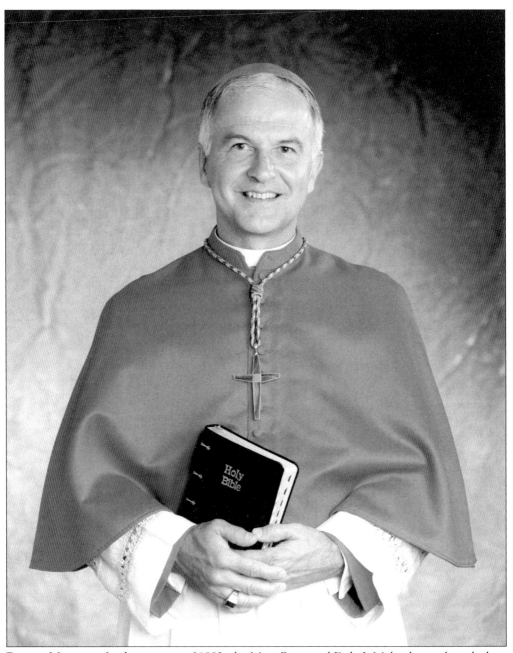

BISHOP MELCZEK. In the summer of 1992, the Most Reverend Dale J. Melczek, auxiliary bishop of the Archdiocese of Detroit, was appointed apostolic administrator of the Diocese of Gary by the late Pope John Paul II. When Bishop Gaughn retired on June 1, 1996, Bishop Melczek became the third bishop of the Gary Diocese. (Courtesy of the Diocese of Gary.)

RENEWAL BOOKLET, 1998. To celebrate the renewal of Holy Angels Cathedral, a solemn mass was held on January 26, 1998. The Most Reverend Dale Melczek, bishop of the Diocese of Gary, presided. A keepsake booklet was provided for all who attended the services. (Courtesy of Calumet Regional Archives.)

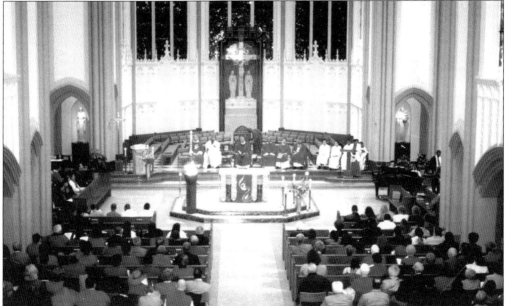

MAIN ALTAR DURING PENTECOST. The renovation of Holy Angels Cathedral, which began in 1997, was quite extensive. Using a special process, workers cleaned all the stained-glass windows and restored them to their original beauty. The main altar was rebuilt, while a new baptismal fount was placed in the main isle. The main altar is pictured during the mass celebrating the Feast of Pentecost. (Courtesy of Holy Angels.)

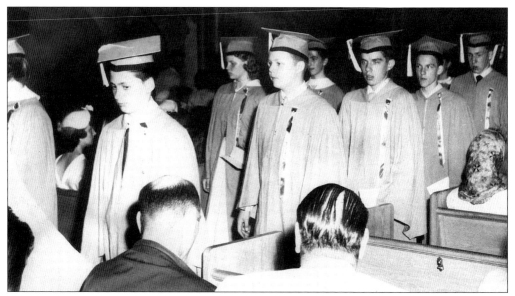

GRADUATION, 1955. Eighth-grade graduates depart as Holy Angels students for the last time in 1955. They leave the cathedral after mass to enjoy the special day and the summer. (Courtesy of Don Mueller.)

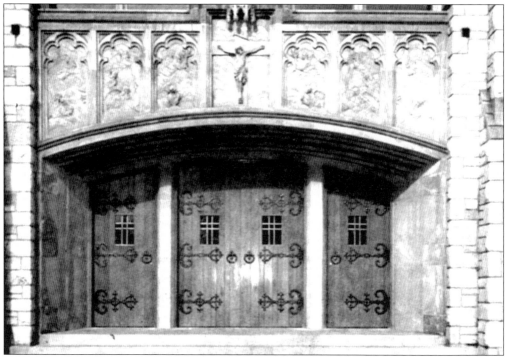

MAIN ENTRANCE TO HOLY ANGELS. During the exterior renovation of Holy Angels Cathedral in the 1990s, the masonry underwent extensive cleaning. When the work was completed on the structure, the intricate details of the stone carvings was restored to its original beauty. The main entrance of the cathedral on Seventh Avenue is pictured. (Courtesy of Calumet Regional Archives.)

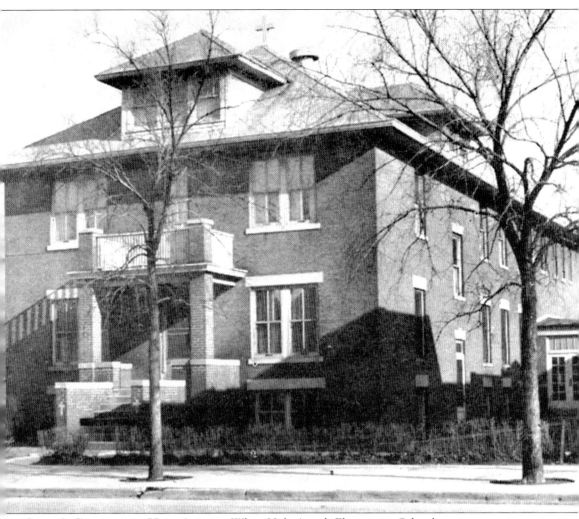

SISTER'S CONVENT AT HOLY ANGELS. When Holy Angels Elementary School was in operation, the Sisters of Notre Dame served as the primary instructors for the parish children. After the school closed, the remaining sisters were assigned to other areas or to the motherhouse. Today it is the home of the resident pastor, Fr. Robert Gehring. (Courtesy of Calumet Regional Archives.)

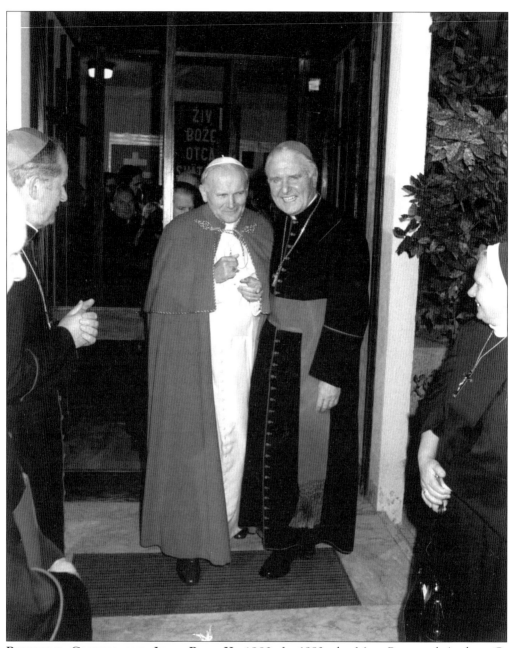

REVEREND GRUTKA AND JOHN PAUL II, 1983. In 1983, the Most Reverend Andrew G. Grutka made his last visit to the Vatican as the bishop of the Diocese of Gary for an audience with the Holy Father. He is pictured with the late Pope John Paul II. (Courtesy of Calumet Regional Archives.)

Six

HORACE MANN

Horace Mann School, located at Fifth Avenue and Garfield Street, first opened its doors in 1928. In the early years, children of all 12 grades were taught there. Named after the 1840s educator and reformer, the school gained prominence in academic excellence and athletic success. Dedicated professionals prepared young minds for college and successful careers in life. In sports, the Horsemen won numerous city and conference titles, and a number of teams earned state titles.

Students who once walked its halls, sat in the classrooms, and took part in extracurricular activities succeeded in college and in the workforce through their efforts and the encouragement of their teachers. A number gained local or national prominence. Alumni included Don Elser, Tom Harmon, James McCraken, Tom Higgins, Marty Shabaz, Eddie Herbert, and Jim Gordon. There were many more.

In 2004, Horace Mann closed its doors. Roy Herold (class of 1946) left a beautiful tribute. "They may tear it down, but Horace Mann will live on until the last graduate passes from this earth, and even then, the stories will have been passed to the next generation. Stories that tell of Gary's Camelot that was once known as Horace Mann School."

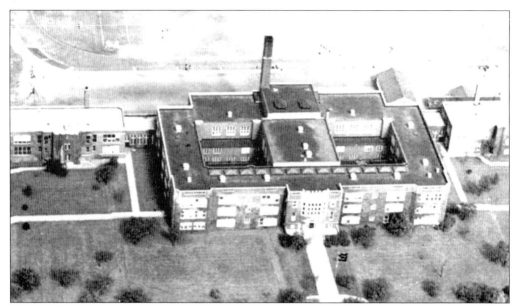

HORACE MANN SCHOOL, 1946. Horace Mann School was designed much like the other high schools in Gary. The main building contained classrooms, labs, an auditorium, and band rooms. Boys' and girls' gyms were on the east and west sides, with a track and practice field to the north. Some old graduates pointed out that a student entered the main doors on the south end and departed on the north side, which faced the mills and their future jobs. (Courtesy of Calumet Regional Archives.)

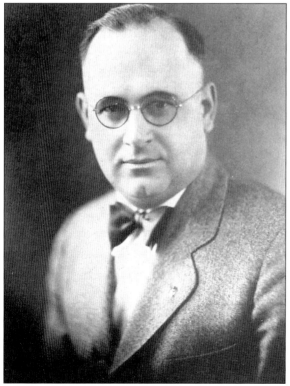

CHARLES D. LUTZ, 1929. Charles D. Lutz, shown here in 1929, was Horace Mann's first principal. He later served as the superintendent of the Gary Public School System. (Courtesy of Calumet Regional Archives.)

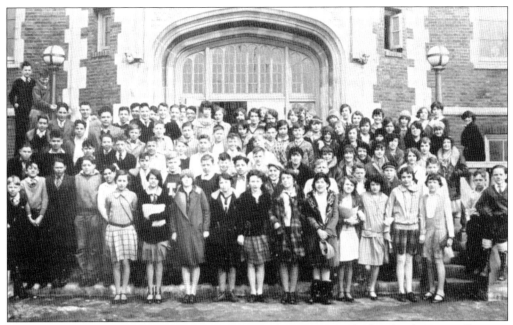

FRESHMEN, 1929. Anyone who looks at their freshman year in high school can recall it as a time of confusion and social trials. But it is also a period of fond memories and the beginning of lifelong friendships. Pictured is the Mann freshman class of 1929. Though the local economy was still good, this group would soon face the hardships of the upcoming Great Depression. (Courtesy of Calumet Regional Archives.)

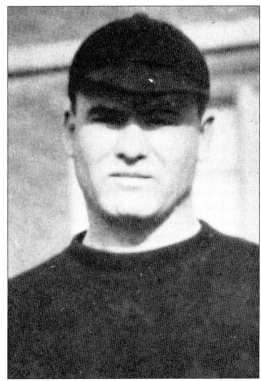

COACH CROWN, 1929. Horace Mann football coach Keith Crown was appointed to organize the program in 1925. In his first four seasons at the helm, Crown guided the Horsemen to three winning seasons and the 1929 Indiana State Football Championship. He is shown here in the fall of 1929. (Courtesy of Calumet Regional Archives.)

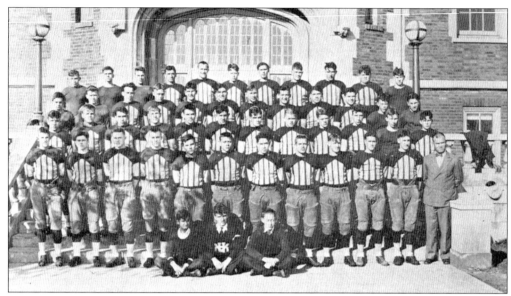

1929 State Football Champs. Horace Mann School and the city of Gary had much to be proud of in 1929. The football team won the Indiana state title with a 38-0 victory over Central High School of Fort Wayne. The Horsemen shut out six opponents that season and took the city title with a 29-0 win against the Froebel Blue Devils. (Courtesy of Calumet Regional Archives.)

Cheerleaders, 1929. To get the student body fired up for the big Friday game, pep assemblies were held in the school auditorium at the end of the class day. Here yell leader Johnnie Doyne leads the Horsemen and their fans in cheers in 1929. The hat is classic! (Courtesy of Calumet Regional Archives.)

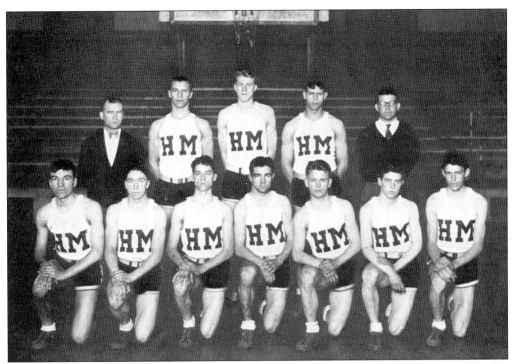

1929 BASKETBALL TEAM. Though the market crash was on its way, the late 1920s were enjoyable times for the city of Gary and Horace Mann. The varsity basketball team would win 26 games and lose 6, place second in the Northern Indiana High School Conference, and win the sectional and regional titles. Pictured are the 1929 team members and their coaches. (Courtesy of Calumet Regional Archives.)

BACCALAUREATE, 1929. It was tradition that before commencement exercises were held, high school graduates attended baccalaureate services. Every year a different neighborhood house of worship invited the school's seniors. In 1929, the First Reformed Church held the ceremonies for the Horace Mann graduates. (Courtesy of Calumet Regional Archives.)

Baccalaureate
Service
Horace Mann School

Gary, Indiana

Eight O'clock p m

Sunday, June 16

1929

First Reformed Church

1929 Commencement Program.
Pictured is the front cover of the
1929 Horace Mann High School
commencement. The inaugural
graduation exercises were held in the
spacious Memorial Auditorium at Seventh
Avenue and Massachusetts. (Courtesy of
Calumet Regional Archives.)

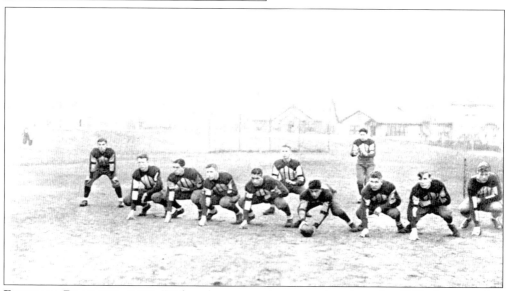

Football Practice, 1930. With only two regulars returning from the 1929 championship
squad, the Horsemen still finished with an impressive 6-2-2 record for the 1930 season. They
are shown practicing their offensive plays for the next game. In those days, players were quite
versatile, as they were expected to play both offense and defense during the games. The basic
offensive attack was run from the old single wing that few, if any, teams use today. (Courtesy of
Calumet Regional Archives.)

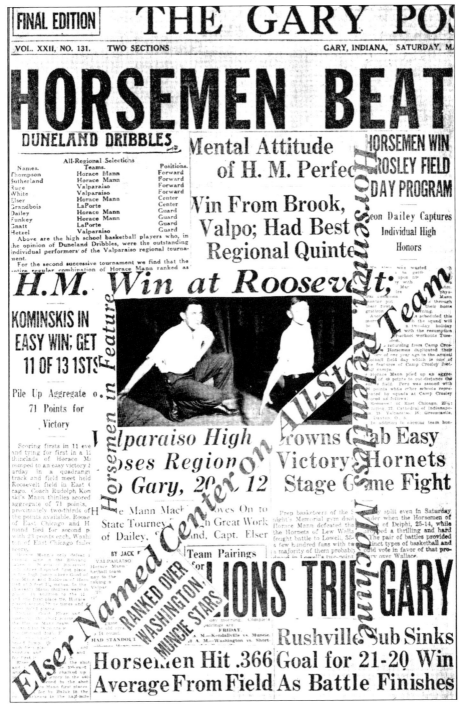

HORSEMEN BEAT

DUNELAND DRIBBLES

All-Regional Selections

Names.	Teams.	Positions.
Thompson	Horace Mann	Forward
Sutherland	Horace Mann	Forward
Ruge	Valparaiso	Forward
White	Valparaiso	Forward
Elser	Horace Mann	Center
Grandbois	LaPorte	Guard
Dailey	Horace Mann	Guard
Funkey	Horace Mann	Guard
Snatt	LaPorte	Guard
Hetzel	Valparaiso	Guard

Above are the high school basketball players who, in the opinion of Duneland Dribbles, were the outstanding individual performers of the Valparaiso regional tournament.

For the second successive tournament we find that the entire regular combination of Horace Mann ranked as

Mental Attitude of H. M. Perfec

Win From Brook, Valpo; Had Best Regional Quinte

HORSEMEN WIN ROSLEY FIELD DAY PROGRAM

eon Dailey Captures Individual High Honors

H.M. Win at Roosevelt;

KOMINSKIS IN EASY WIN; GET 11 OF 13 1STS

Pile Up Aggregate o. 71 Points for Victory

Scoring firsts in 11 eve and tying for first in a 1 thinclads of Horace M romped to an easy victory arday in a quadrangl track and field meet held Roosevelt field in East (cago. Coach Rudolph Kom ski's Mann thinlies scored aggregate of 71 points, practically two-thirds of H the points available. Roose of East Chicago and H mond tied for second p with 23 points each. Washi n of East Chicago faile scorc.

lparaiso High ses Region o Gary, 20 12

e Mann Mack oves On to State Tourney h Great Work of Dailey, and, Capt. Elser

rowns Gab Easy Victory Hornets Stage G me Fight

Prep basketeers of the S night's Memorial gym doubl Horace Mann defeated the the Hornets of Lew Walla fought battle to Lowell, 38- a few hundred fans with tw a majority of them probabl in Lowell's two-point

BY JACK F
VALPARAISO
Horace Mann ketball team ney to the aking a d

Team Pairings for

RANKED OVER WASHINGTON, MUNCIE STARS

LIONS TRI GARY

Rushville ub Sinks

Horsemen Hit .366 Goal for 21-20 Win Average From Field As Battle Finishes

Horsemen in Feature — *Relentless Machine* — *All-Star Team* — *Elser Named Center on*

MANN SPORTS HEADLINES, 1929. Radio was still in its infancy in 1929, so local high school contests were not carried over the airways. Team supporters who could not attend the game had to rely on the local newspapers such as the *Gary Post-Tribune* and the *Hammond Times* to get an accurate account of the game. Pictured are some of the basketball headlines from Horace Mann's 1929 season. (Courtesy of Calumet Regional Archives.)

MANN YEARBOOK, 1931. Students, staff, and teachers devoted a great deal of time and effort into the publication of their yearbook, the *Horace Manual*. The front covers of the annuals of the 1930s were classic, as they displayed a raised image tied to the book's theme or a symbol of the Calumet Region. The 1931 cover depicted the smokestacks of the steel industry. (Courtesy of Calumet Regional Archives.)

DEPRESSION YEARBOOK, 1933. In the early 1930s, the nation faced an economic nightmare with the Depression. Money was tight and few families could afford the added expense of a yearbook. Lulu Pickard and her staff published their own for the students of 1933. Pictured is the cover of the *Horace Manual* Depression issue. (Courtesy of Calumet Regional Archives.)

THE

HORACE MANUAL
DEPRESSION ISSUE

Published

by

THE CLASS
of
1933

Vol. V

SPONSORED BY
Mrs. Lulu Pickard

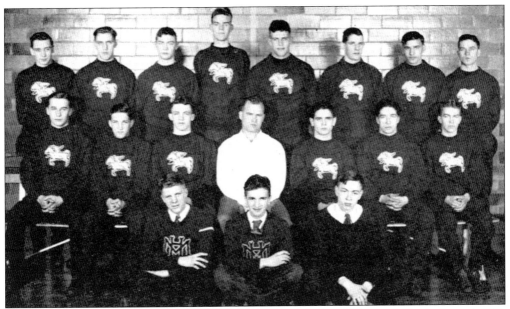

BASKETBALL SQUAD, 1931. Finishing the regular season below .500, coach Keith Crown's 1931 squad became the surprise of the region in the tournament. The Horsemen won the sectional and regional titles and finally lost in a squeaker 21-20 to Rushville. (Courtesy of Calumet Regional Archives.)

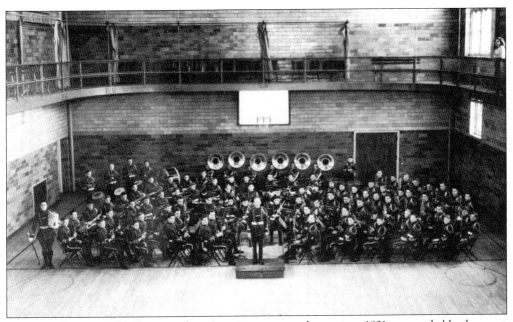

CONCERT BAND, 1931. For countless Americans across the nation, 1931 was probably the most challenging year of the Great Depression. Many students had to leave school and find some type of work that would bring in additional income for their families. Yet for those who where able to continue their education, various extracurricular activities provided temporary escape from the hard times. Here the 1931 Concert Band prepares for practice. (Courtesy of Calumet Regional Archives.)

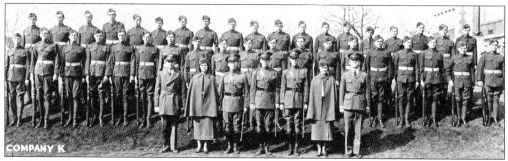

1932 ROTC. Part of the curriculum at many Gary high schools during the 1930s was the junior Reserve Officers Training Corps. Pictured are cadets from Company K. Cadet officers in Company I wore riding boots similar to those worn today by cadets at Texas A&M University. (Courtesy of Calumet Regional Archives.)

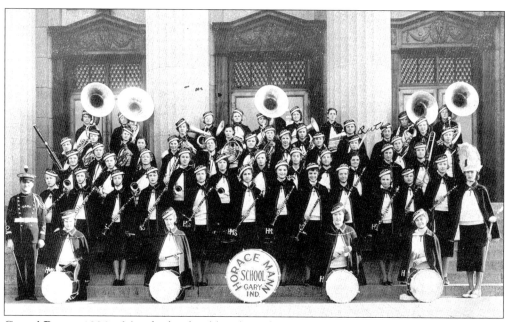

GIRLS' BAND, 1930s. Most high school bands in the 1930s were still all male. But since a large number of young ladies were gifted with musical talents, Horace Mann High School had its own girls' band. (Courtesy of Calumet Regional Archives.)

TOM HARMON, 1939. Tom Harmon (class of 1937) was an all-around athlete in football, basketball, and track. He made All-American honors at the University of Michigan. The veteran of World War II settled on the West Coast and hosted a sports radio show. His son Mark appears on the CBS television show *NCIS* (Courtesy of Calumet Regional Archives.)

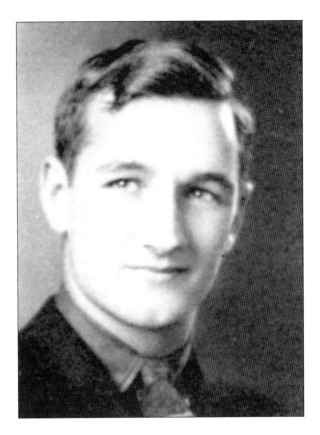

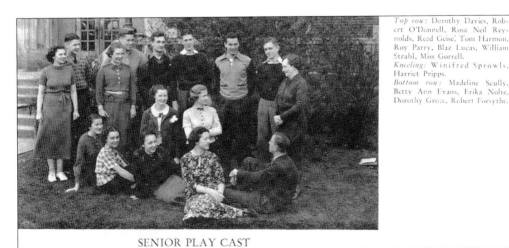

Top row: Dorothy Davies, Robert O'Donnell, Rosa Neil Reynolds, Reed Geise, Tom Harmon, Roy Parry, Blaz Lucas, William Strahl, Miss Gorrell.
Kneeling: Winifred Sprowls, Harriet Pripps.
Bottom row: Madeline Scully, Betty Ann Evans, Erika Nolte, Dorothy Grote, Robert Forsythe.

SENIOR PLAY CAST

HARMON IN PLAY, 1937. Blessed with superior athletic skills, Tom Harmon also had a talent for the stage. He is seen here as part of the cast in the senior play in 1937. (Courtesy of Calumet Regional Archives.)

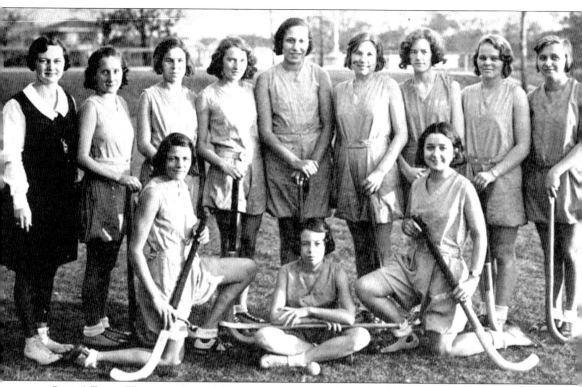

GIRLS' FIELD HOCKEY. One of the sports open to girls in the 1930s was field hockey. Due to limited athletic budgets or lack of interest, the sport is not offered in many area schools today. Pictured is the 1931 Horace Mann girls' varsity field hockey team with their coach, Cecilia J. Danner. (Courtesy of Calumet Regional Archives.)

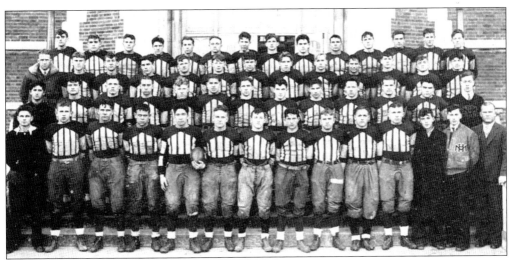

FOOTBALL TEAM, 1931. The 1931 Horace Mann football team completed a successful season with a 6-2-2 record. The Horsemen rode to victories over such rivals as Mishawaka, East Chicago Roosevelt, and Emerson. On October 3, they defeated Bronson Hall of Notre Dame 12-6. (Courtesy of Calumet Regional Archives.)

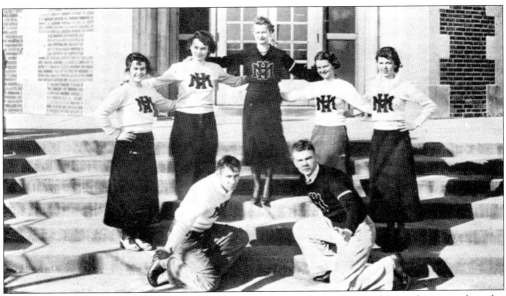

CHEERLEADERS, 1935. The uniforms and cheer routines have changed over the years, but the task of the cheerleaders has been the same—to fire up the home crowd every game. Pictured are the varsity cheerleaders in 1935. (Courtesy of Calumet Regional Archives.)

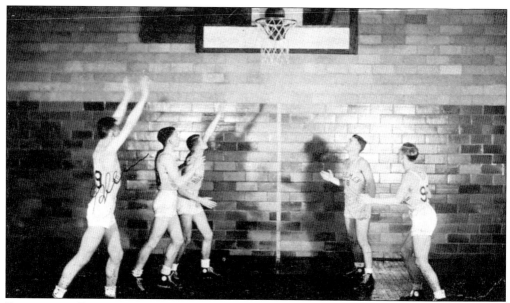

BASKETBALL PRACTICE, 1935. In the early days of high school basketball, the games were usually low-scoring affairs. Players ran patterns, took two-handed set shots, and everyone knew how to play defense. Slam dunks did not exist. Here the 1934–1935 Mann team runs a staged practice for the photographer. (Courtesy of Calumet Regional Archives.)

MANN SCHOOL NEWSPAPER, 1945. The *Mann-U-Script* became the school's official newspaper in 1937. Prior to that, the students wrote and published the news themselves. In 1945, Emma Peters was the faculty advisor for the journalism students. A biweekly publication covered school news and sports and included feature columns such as the "Gospel Truth" and "Monograms." Pictured is the 1945 staff of the *Mann-U-Script*. (Courtesy of Calumet Regional Archives.)

To those Horace Mann students who sacrificed their lives that peace might again be shared by all the world, we reverently dedicate this page.

★★★

KILLED IN UNITED STATES

Lawrence Barrett—air crash—California—Nov. 12, 1941

Michael Baran—air crash—Oklahoma—October 21, 1943

Robert Beckham—Georgia—September 18, 1944

James Briggs—air crash—Idaho—July 16, 1942

Joseph Brennan—air crash—Michigan—April 10, 1945

Keith Jessup—air crash—South Carolina—March 31, 1943

Russell Johnson—air crash—Texas—March 20, 1944

Bill Kettler—drowned—New Jersey—October 25, 1943

Donald Orth—air crash—California—April 9, 1944

Charles O'Donnell—air crash—Indiana—November 21, 1942

Robert Tittle—air crash—Minnesota—April 3, 1944

John Wirth—air crash—California—April 12, 1945

Edward Zukowsky—air crash—So. Carolina—April 27, 1944

KILLED IN ACTION

Ernest Brown—Escanaba—June 18, 1943

Bill Carpenter—Alaska—June 23, 1943

Charles Davidson—Holland—October 12, 1944

Robert Cherock—Pacific—August 18, 1944

Max Hindman—Germany—November 27, 1944

Robert Karie—Iwo Jima—March 4, 1945

Herman Kutch—Pacific—July 26, 1944

Hobart Kemp—Pacific—February 29, 1944

Gordon Landeck—Philippines—November 28, 1944

Robert McGhee—Rendova Island—November 1, 1943

Charles Muir—Italy—March 10, 1944

James Ruchti—Africa—December 5, 1942

Emory Saydos—Europe—October 11, 1944

John Studness—Luxembourg—January 10, 1945

Joseph Toskody—France—June 29, 1945

Robert Troutman—Germany—July 27, 1944

MISSING IN ACTION

Stanley Dec—Luxembourg—December 20, 1944

Theodore Esposito—Germany—December 6, 1944

Harry Foster—Italy—April 28, 1944

James Frischkorn—Philippines—February 8, 1945

George Good—Bay of Biscay—August 17, 1943

Harold Hilty—Italy—January 22, 1944

Jack Juras—Germany—May 1, 1944

John Larson—New Guinea—June 11, 1944

Edgar Meyers—France—January 1, 1945

David MacCleod—South Pacific—April 17, 1945

Calvin Shahbaz—Germany—February 26, 1945

George Sirko—Luxembourg—December 20, 1944

Ralph Snyder—Germany—November 27, 1944

Gordon Vilberg—Haninak—March 6, 1945

PRISONER OF WAR

Vernon Albares—Germany—June 14, 1944

Wayne Cuppett—Germany—March 30, 1944

Lloyd Cond—Tokyo—August 10, 1943

Ken Matson—Germany—November 5, 1943

Raymond McCormick—Romania—April 4, 1944

Steve Souris—Germany—November 15, 1943

★★★

SERVICEMEN FROM MANN. To honor Horace Mann graduates who served in World War II, the school printed their names in the 1945 yearbook. Those killed in action and those who were lost while serving in the United States were listed. Included were those missing in action and prisoners of war. Over two dozen students gave the ultimate sacrifice for their country. They were all part of America's Greatest Generation. (Courtesy of Calumet Regional Archives.)

HORACE MANNUAL, 1945 COLLAGE. For Horace Mann Seniors, 1945 was a special year to remember. Though the war was still being waged on two fronts, student life continued. A collage of pictures presents memorable moments of a time of sacrifice and hope. (Courtesy of Calumet Regional Archives.)

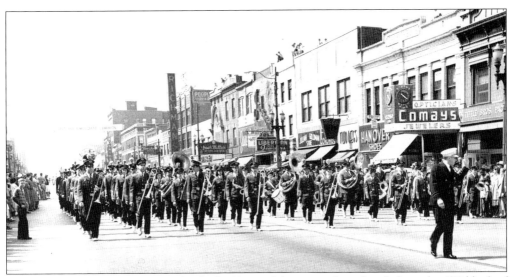

MANN BAND, 1950S. Ken Resur leads the Horace Mann marching band along the 600 block of Broadway in the 1950s. Under his direction, the band won numerous competitions that earned state and national recognition. (Courtesy of Calumet Regional Archives.)

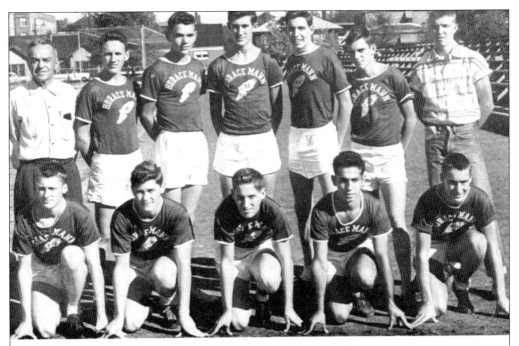

Cross Country

Row 1–Gilbert Kelley, William Lemmons, Donald Bucheck, Jesse Pera, James Gude

Row 2–Coach Kominski, Terry Murray, Donald Fekete, John Someson, Rollin Geddes, Kenneth Nelson, James Uhles

CROSS-COUNTRY, 1956. The 1956 Horace Mann cross-country team won the city championship under coach Kominiski. (Courtesy of Calumet Regional Archives.)

CHEERLEADERS, 1956. The varsity cheerleaders pose for their picture near the school pond in 1956. (Courtesy of Calumet Regional Archives.)

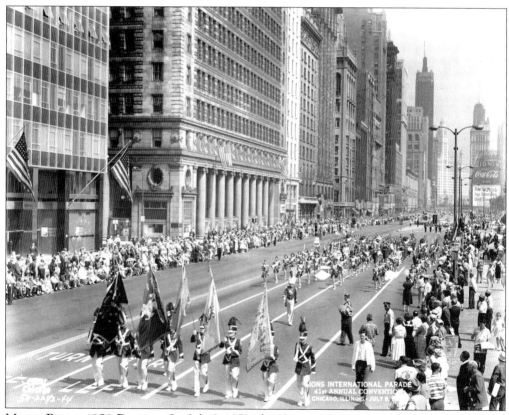

MANN BAND, 1958 PARADE. On July 9, 1958, the Horace Mann marching band took part in the Lions International Parade in Chicago, Illinois. The band is seen here marching south along Michigan Avenue. (Courtesy of Calumet Regional Archives.)

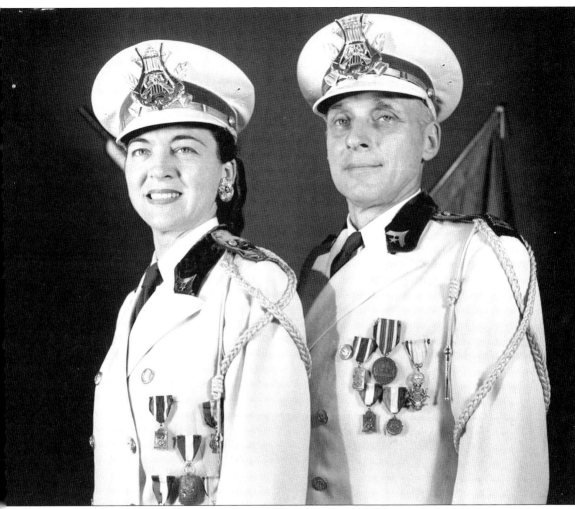

ANNE AND KEN RESUR. Anne and Ken Resur, the Calumet Region's legendary first couple of music, gave many years of dedicated service to Horace Mann's music department. Anne was the director of the majorettes, while Ken, the band director, developed an award-winning program. They are pictured in the late 1950s. (Courtesy of Calumet Regional Archives.)

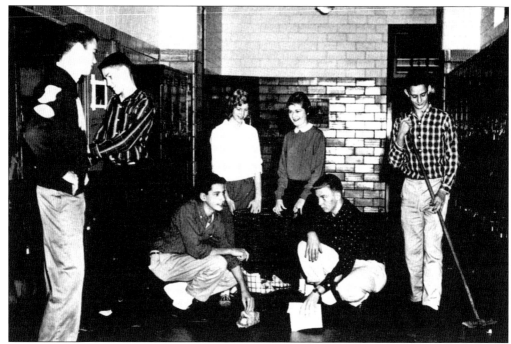

STUDENT COUNCIL AND GROUNDS COMMITTEE. Keeping the hallways neat and presentable provided a positive image of Horace Mann to parents and visitors. Here student council members of the Grounds Committee clean up paper and debris in 1958. Since recycling was not encouraged yet, all trash went to the city landfill. (Courtesy of Calumet Regional Archives.)

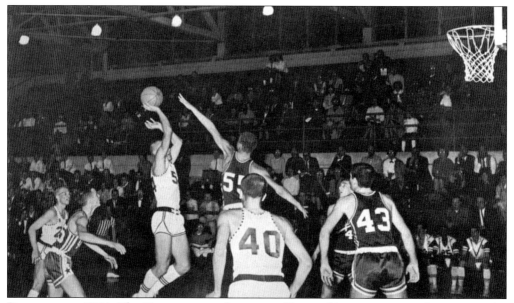

BASKETBALL, 1964. The Horsemen are shown on offense taking a two-point shot against the Valparaiso Viking defense. The game was played in the old Valpo gym in 1964. (Courtesy of Calumet Regional Archives.)

COLONEL BORMAN. Astronaut Frank Borman and his crew had orbited the earth as part of the Gemini Program in the mid-1960s. Later he commanded the crew of *Apollo 8*, which was the first American craft to orbit the moon. Colonel Borman and his family lived in the Horace Mann community for six years. (Courtesy of Calumet Regional Archives.)

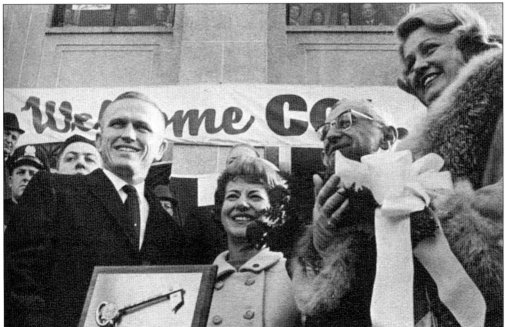

BORMAN AND KATZ. In January 1966, space astronaut Col. Frank Borman, was given a hero's welcome by the city of Gary with a parade, civic luncheon, and a special program at Memorial Auditorium. Here Colonel Borman is given the key to the city by Mayor A. Martin Katz in front of city hall. On Christmas Eve 1968, Borman's Apollo crew orbited the moon. (Courtesy of Calumet Regional Archives.)

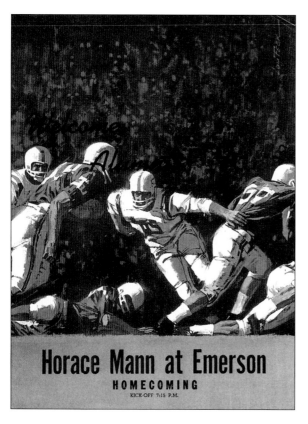

HORACE MANN-EMERSON FOOTBALL PROGRAM, 1967. In late October 1967, Horace Mann's football squad met longtime rival Gary Emerson at Gilroy Stadium. In a game filled with penalties, the Horsemen prevailed over the Golden Tornado 13-9, sending the students and alumni home happy. For the Eastsiders, it was a painful homecoming loss. Shown above is the 1967 game program.

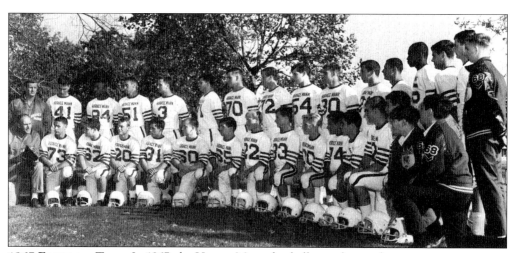

1967 FOOTBALL TEAM. In 1967, the Horace Mann football team began the season on a sour note, losing to Roosevelt, Valparaiso, and Lew Wallace. But coach Don Elser's squad turned the season around by winning six of its last seven contests. The only blemish was a 7-7 tie with the Warriors of Bishop Noll. It was an amazing turnaround. (Courtesy of Calumet Regional Archives.)

TWIRP WEEK, CARRYING BOOKS. Reversed roles were the order of the week for the young ladies of Mann in 1970. It was Twirp week and the school's female population took the roles of gentlemen and performed the duties expected of the males. One girl gets a workout carrying books for a guy who probably never carried such a load during the entire school year. (Courtesy of Calumet Regional Archives.)

PROPER DRESS. Sue Darnell makes sure that Dennis Harrington is dressed properly from head to toe by tying his shoelaces. It may not be considered politically correct today, but it was all in fun over 30 years ago. On Friday of Twirp week, a turnabout dance concluded the activities. (Courtesy of Calumet Regional Archives.)

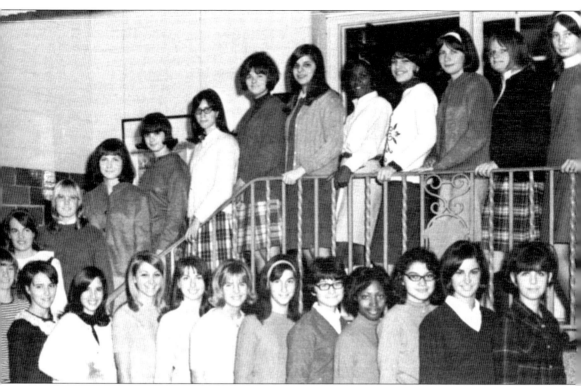

BOOSTER CLUB, 1967. Mann's Booster Club worked on many school activities such as homecoming and dances. They raised money for the cheerleaders' uniforms and sponsored the Yell Club. The ladies of the 1967 club are pictured. If any gentlemen were allowed to join, they would have no excuses in finding a date. (Courtesy of Calumet Regional Archives.)

PROM ARRIVAL, 1964.
If all the planning and work was complete, the annual junior-senior prom became an enjoyable affair. Girls picked their dresses, got their hair done just right, and hoped that their dates purchased the right color of flowers to match their formals. Guys worked for extra money and hoped to borrow the family car for the special evening. The arriving couple shows that chivalry was alive and well in 1964. (Courtesy of Calumet Regional Archives.)

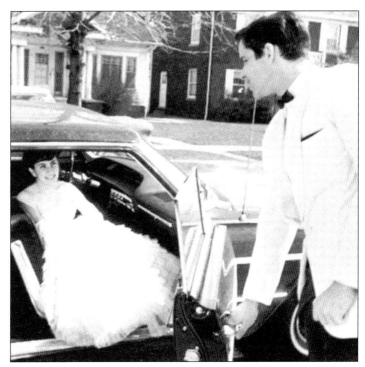

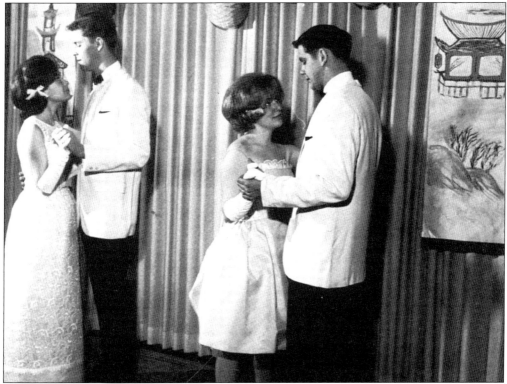

PROM DANCE, 1964. Couples enjoy the dance music during the 1964 prom. (Courtesy of Calumet Regional Archives.)

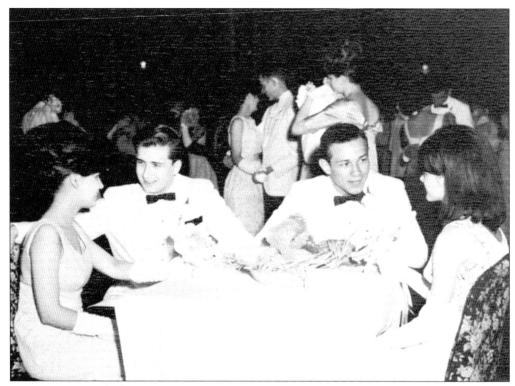

PROM, 1967. With the coming of spring, the thoughts of many upperclassmen turned to the junior-senior prom. Girls looked forward to being asked by the special someone. Many guys just hoped they could muster the courage to ask. Pictured are couples taking a break at Marquette Park Pavilion in 1967. The hairstyles seem to take a person back to an era long, long ago. (Courtesy of Calumet Regional Archives.)

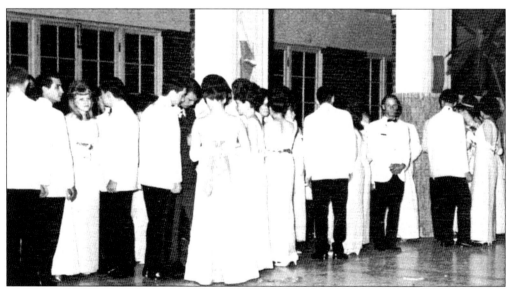

PROM 1967, GRAND MARCH. Couples prepare for the Grand March at Marquette Park Pavilion. (Courtesy of Calumet Regional Archives.)

HOMECOMING, 1970. Homecoming was always a grand time during the football season for students, parents, and alumni. The traditions go back to the days of knights competing for the lady's colors. In the modern contest, the athletes in their school colors do battle with their opponents while the homecoming queen and her court look on with their partisan fans. (Courtesy of Calumet Regional Archives.)

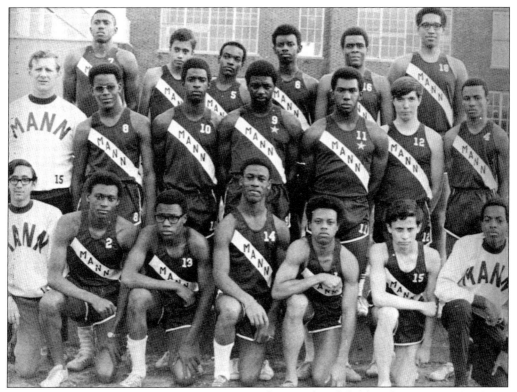

TRACK TEAM, 1970. In 1970, Horace Mann's track team placed third in the city meet. However, in the state competition that year, the team placed a respectable fourth in Indianapolis. Pat Gullett, a junior, won the state championship in the 220-yard dash. He had already won the city title in the 100- and 220-yard dashes. (Courtesy of Calumet Regional Archives.)

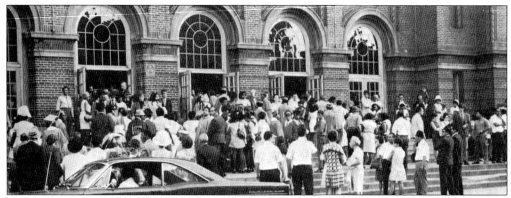

GRADUATION, 1970. Commencement exercises were held at Memorial Auditorium for over 40 years. Here the families and friends of the graduates meet in front of the main entrance in 1970. By the mid-1970s, graduation ceremonies were moved elsewhere. (Courtesy of Calumet Regional Archives.)

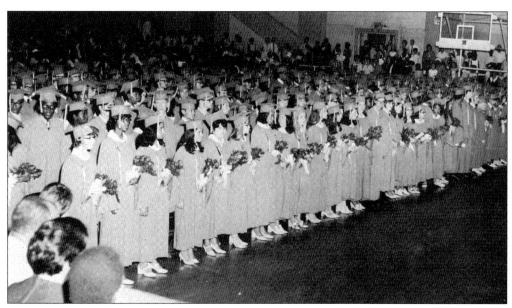

COMMENCEMENT CEREMONIES, 1970. Finally after four years, it was all over for the class of 1970 as they received their diplomas at the commencement ceremonies at old Memorial Auditorium. As with every graduation, it would be the last time the seniors would be together before they went off into the world. (Courtesy of Calumet Regional Archives.)

the horace mannual
1964 edition

horace mann high school

A LAST FAREWELL. In 2004, the halls were emptied, the lights turned off, and the doors closed for the last time, but the memories and friendships would endure. (Courtesy of Calumet Regional Archives.)

Bibliography

Cohen, Ronald D., and Lane, James B. *Gary, A Pictorial History*, 1983 and 2003.
http://www.post-trib.com.
Lane, James B. *City of the Century, A History of Gary, Indiana*, 1978.
Mohl, Raymond A., and Betten, Neil. *Steel City, Urban and Ethnic Patterns in Gary, Indiana 1906-1950*, 1986.
Moore, Powell A. *The Calumet Region, Indiana's Last Frontier*, 1959.

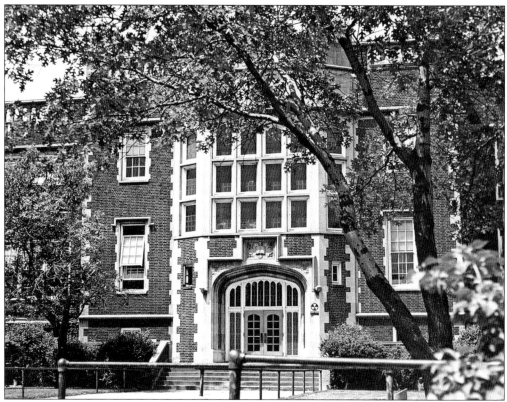

MANN FRONT ENTRANCE, 2005. The words from "Horace Mann Loyalty" remain in the hearts of its graduates: "Onward ever, Forget you never, O Horace Mann we're true!" (Courtesy of Calumet Regional Archives.)